Chris Marker
La Jetée

Janet Harbord

One Work Series Editor
Mark Lewis

Afterall Books Editors
Charles Esche and Mark Lewis

Managing Editor
Caroline Woodley

Associate Editor
Melissa Gronlund

Copy Editor
Deirdre O' Dwyer

Picture Editor
Gaia Alessi

One Work is a unique series of books published by Afterall, based at Central Saint Martins College of Art and Design in London. Each book presents a single work of art considered in detail by a single author. The focus of the series is on contemporary art and its aim is to provoke debate about significant moments in art's recent development.

Over the course of more than one hundred books, important works will be presented in a meticulous and generous manner by writers who believe passionately in the originality and significance of the works about which they have chosen to write. Each book contains a comprehensive and detailed formal description of the work, followed by a critical mapping of the aesthetic and cultural context in which it was made and has gone on to shape. The changing presentation and reception of the work throughout its existence is also discussed, and each writer stakes a claim on the influence 'their' work has on the making and understanding of other works of art.

The books insist that a single contemporary work of art (in all of its different manifestations), through a unique and radical aesthetic articulation or invention, can affect our understanding of art in general. More than that, these books suggest that a single work of art can literally transform, however modestly, the way we look at and understand the world. In this sense the *One Work* series, while by no means exhaustive, will eventually become a veritable library of works of art that have made a difference.

First published in 2009
by Afterall Books

Afterall
Central Saint Martins
College of Art and Design,
University of the Arts London,
107—109 Charing Cross Road,
London WC2H ODU
www.afterall.org

ISBN Paperback: 978—1—84638—048—8
ISBN Cloth: 978—1—84638—049—5

Distribution by The MIT Press,
Cambridge, Massachusetts and London
www.mitpress.mit.edu

Art Direction and Typeface Design
A2/SW/HK

Printed and bound by
Die Keure, Belgium

The *One Work* series is printed
on FSC certified papers

Images courtesy the artist.

Chris Marker
La Jetée

Janet Harbord

I would like to thank Sarah Turner for her magical thinking during the writing of this book, and for embarking on time travel with me wherever that happens to lead. My thanks also to Rosa Ainley, Jo Henderson and Rachel Moore for inspiration and their many and generous forms of support. Finally, my gratitude goes to the students I have shared this film with, and who have suffered my experiments with nothing less than good humour.

Janet Harbord is Reader in Film and Screen Media at Goldsmiths, University of London. She writes for various journals and magazines on the changing life of film in the wake of digitalisation, and is the author of *The Evolution of Film* (Polity, 2007) and *Film Cultures* (Sage, 2002). She is currently working collaboratively on a Leverhulme-funded project, 'Spaces of the Screen', and writing a book on moving-image culture and practices of montage.

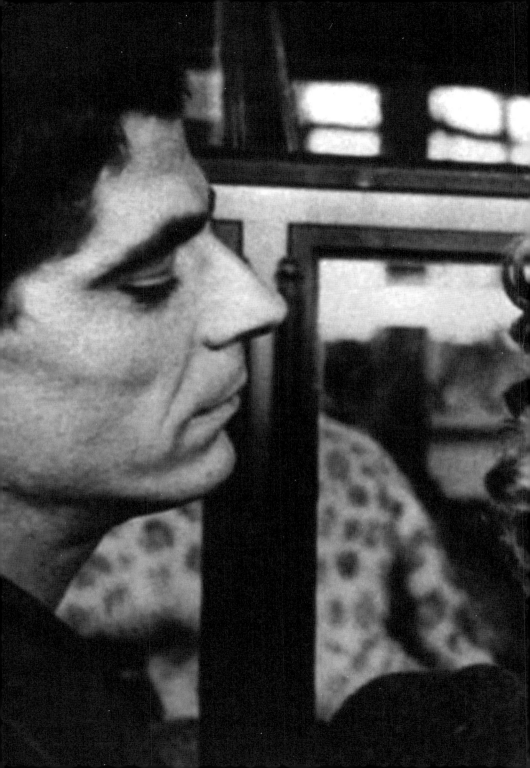

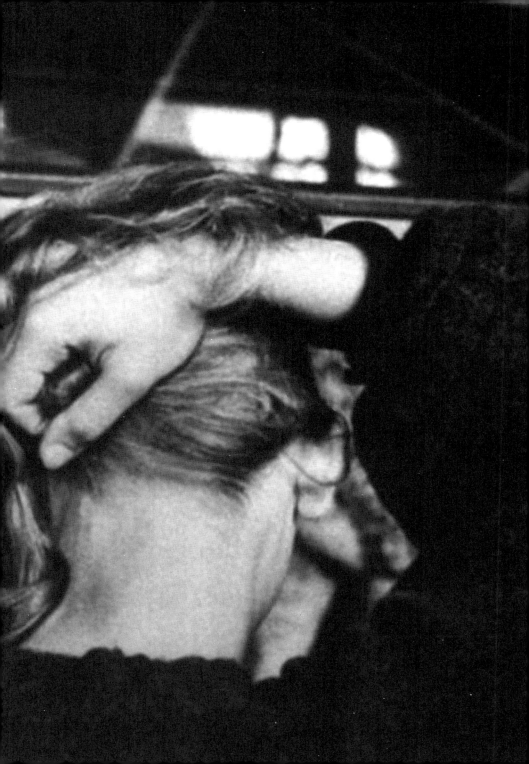

La Jetée (1962) is a *ciné-roman*, a film-novel that operates within the strictest of economies. It is a film composed almost exclusively of still images, with the bare essentials of a story told in voice-over. It is an extraordinary film of 'a man marked by an image from his childhood', and it opens with a replay of this childhood moment. These are the 'facts', although facts benefit us little in this particular story. In the circular movement of the film, in which the end arrives at the beginning and so the beginning is also the ending, the concrete facts do not add up to much. A child witnesses his own death as a man, defying the premise of chronological time. We are told that the child sees the man (his future self) fall to the ground. We see the falling figure but we are left with an uncertainty concerning the whereabouts of the child; perhaps that is him, poised precariously on the railing, but we cannot be certain. If this is the story of a man's recall of a moment as a boy, where, in memory, is the mind's eye? The perspective in this opening sequence seems to place us above or outside of the scene, as if captured through a crane shot followed by a tracking shot showing a scattering of people. That is, the act of remembering appears to be cinematic, which leads to a query of a different order. Not only are the positions of boy and man, and past and future, indistinguishable, it's also possible that memory is inseparable from the staging, framing and focal devices of cinematic photography. How is it that memory is infected by the photographic, and, conversely, that photographic devices have come to serve the requirements of memory?

But we are forgetting something before this, before the child and the man falling. To begin again with what comes first, there is a sound, the rising blast of an aircraft engine. This sound is followed by an image of Orly Airport,

the observation pier stretched out in a line cutting diagonally across the screen, top right to lower left (fig.1). Aeroplanes are aligned in a state of rest along the edge of the pier, a few cars and buses parked within grids painted onto the tarmac. Shot from above, the scene is miniaturised. It is a child's view of a scene of industry, like a play map, reassuring in its simple functionality. But before we can get our bearings, we are swept up by the rush of mechanical sound and carried into movement across the still image. The camera zooms out from a fixed focal point, so that it feels as though we are moving backwards and forwards in the same moment.[1] Here then, the orientation shot provides disorientation, and propels the action forward whilst moving backwards. Rushing towards and away at the same time, we are thrown in the opposite directions of recollection and anticipation. The still photograph evokes remembrance, the memory of this place on this day. But the movement across its still surface creates an anxiety about what we are moving towards. This is not a film composed of still images, where both cinema and photography remain distinct. This is a film that finds qualities of movement and stillness in each, that braids together remembering and forgetting, that points us in conflicting directions.[2] The first image prepares us for the ride.

The film opens with the drama of aircraft running parallel to the story, with these machines that travel in space parallel to cinema's travelling in time. The enchantment of cinema as time travel, however, covers over the empirical matter that films themselves journey in space and time. Whilst *La Jetée* famously asks us to consider the contortions of travelling between designated tenses, we might also wonder what happens to a film — this film

— over distance and time? Does something accumulate
as a film ages, and if so, with what kind of substance is
it that we are left? Does this substance adhere to the film,
to scratch and sparkle on its surface, or does something
accrete to each of us separately or collectively about the
memory of the film? My recall of this work lacks a singu-
lar instance, an origin. There is no one memory of a then
and a there, but instances and repetitions whose times are
fittingly muddled across viewings. There are cinemas and
lecture halls, packed auditoriums and quasi-empty rooms,
jittery projectors and modern disc machines. As a memory,
La Jetée is a series of superimpositions, images that surface
variously: scenes of scientists conducting experiments on
human subjects, a glaring cat in a pose of hostility, a couple
pointing, a walk in a park; and then of heads floating in a
sea of darkness; and of statues, many broken statues. There
is also a whispering gallery of voices, a summer afternoon
of bird noise, choral music that lifts upwards and out of
a broken cathedral roof and the clipped formal tone of an
authoritative voice. I cannot be sure whether I can separate
out various memories of watching the film, because what
binds them all is a gasp, a collective bodily intake of breath
in every auditorium and theatre and lecture hall, when a
woman on the screen opens her eyes, looks at us and blinks,
when the film slips from still images to a brief sequence
of movement. It is a gasp close to an experience of the erotic
or the religious or possibly both.

To blink (a word of uncertain origin) is to foreclose vision,
to create a break in seeing. Blinking is maybe a bodily
form of editing. The film's brief animation of a woman as
she blinks plays back to us the conditions of the cinematic
experience: we see images but there is an interposing leaf,
a blackness that gets in between. Black leader leading us

or leaving us to our own thoughts — or, rather, black leader that imposes a gap in vision — is a critical component of the film. In the structure of seeing and not seeing lies the kernel of the idea of memory, of what we remember and what we forget, demonstrating how remembering and forgetting are not oppositional acts but two sides of the same coin. 'I will have spent my life trying to understand the function of remembering,' says the narrator in another of Marker's landmark films, *Sans Soleil* (*Sunless*, 1983), 'which is not the opposite of forgetting, but rather its lining'. The comment recalls Nietzsche writing that there could be no hope, 'no *present*, without forgetfulness',[3] as well as Kafka's statement: 'One photographs things in order to get them out of one's mind. My stories are a kind of closing one's eyes.'[4] We close our eyes, like the cinema's blink to blackness, and we dream of what has been and might be. Forgetting is not an abandonment of the past, but permission to elaborate, to reconstruct differently, to mix up the syntax. Both memory and cinema work with an unstable set of associations, contingent on the circumstances in which they appear. If the potency of a memory is the opening enigma of *La Jetée*, the rest of the film is an exploration of the ways in which recording devices, such as film and photography, perform a choreography with memory's work.

Return and Repetition

In less than 29 minutes, the film takes us into a projected present, a fabricated past and an imagined future. *La Jetée* is the story of a man who travels through time to secure the future of humanity in a post-apocalyptic context. It is a story of heroism but also risk. The potency of images from his childhood enables the man to move through time zones, but his strength of imagining contains the seeds of his

own demise. The images of childhood that compel him turn out to be the scene of his own violent death. Choosing to return to the past, drawn to a woman waiting there, he is shot down on an airport observation pier in the final sequence of the film, reliving the scene he has once glimpsed.

La Jetée is a story about going back. It tells of a man whose desire is to return to the past, and as such it is a film that echoes other stories, cultural myths that are full of warning. Orpheus loses his lover through a backward glance. Oedipus blinds himself after returning to his mother. In Alfred Hitchcock's *Vertigo*, Scottie falls foul of a desire to re-stage his relationship with a woman, to consciously turn back the clocks.[5] And it echoes the (often misplaced) desire of many *noir* films, to go back and reconstruct the past in order to elucidate a truth about a woman. Going back is not something that one can get away with. In the common fate of these stories, it is an aberrant desire that meets punishment. We know when the protagonist of *La Jetée* faces the choice of living in the future or returning to the past that his choice of the past is portentous. The man wishes to return to a former moment, a 'twice-lived' moment of time. His fate is sealed by a desire for repetition, for an identical match, to experience the moment as it was then. The moment of the woman's awakening demonstrates the force of the current, of how the past can hold us in its thrall to the point where it assumes the features of the present. In this particular film, Marker allows us to experience memory and remembering both ways. It is the seduction of the past that lives with us and to which we are ineluctably drawn. And it is the need to grasp the matter of what has been in order to re-make it differently.

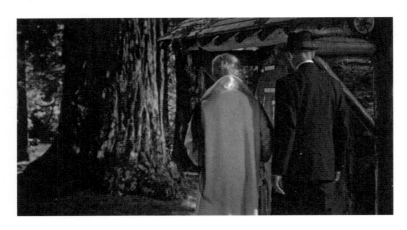

Alfred Hitchcock,
Vertigo,
35mm Technicolor film,
129min, 1958

We have a saying, which might be one very much of 'our' times, that it isn't possible to live in the past. Interestingly, we have few expressions for how the past lives with us. That Marker in 1962 would have wanted to dislodge the complacency of historical perspective in French post-colonial culture is indisputable.[6] It was the year in which he made two films: *Le Joli mai*, a documentary consisting mostly of interviews with French citizens, and *La Jetée*. The first film, surveying the opinions of individuals on questions of social connection and political awareness, directly confronts the political moment of the Evian Accords, when the Algerian War (1954–62) was finally brought to a close. The direct style of the documentary drew critical responses from some quarters, ranging from accusations that Marker created or enhanced some of the interviews during the editing process to the labelling of his style as didactic. In *La Jetée*, by contrast, Marker created a tightly woven, futurist fiction. Yet these two radically different films might be regarded as mirroring each other in an inversion of technique and genre.[7] Describing the impulse to make *La Jetée*, Marker has remarked that he began to shoot images for a story he 'didn't completely understand', as though *La Jetée* were almost an unconscious rendition of contemporary anxieties.[8] Notably, he started shooting *La Jetée* in down time, on a day off in the making of *Le Joli mai*. But we can go further back to other histories that press in on the film. The collective trauma of World War II is evident. The images of life in the underground camp echo the conditions of the Holocaust, and those of the post-apocalyptic ruins evoke bombed-out European cities. The devastated landscape described by the narrator also recalls the poisoned remains of Hiroshima and Nagasaki. Added to the weight of the past, the global

political anxiety of the Cuban missile crisis in October 1962 brought the possibility of future wars into focus. In *La Jetée*, it is not simply that the past presents material to be reworked, but that its reworking is directed at the future.

In thinking of the past, as Marker shows us, we are automatically bound to the other terms of the triad: the present and the future. If *La Jetée* speaks of the inseparability of these terms, philosophical enquiry allows us to see the various framings of their relation. During the twentieth century there were, at least, four frameworks that came to dominate thought on this subject. The first of these is the Marxist insistence on the importance of the past in historical materialism, where an accumulation of events over time reveals a fracture under the pressure of contradictory interests. The dialectical movement of history allows moments of the past to reappear as flashes, in sudden juxtaposition to the present, forcing a rent in the social fabric and a rupturing of our sense of time as simply a continuum. From this rupture, the new emerges, yet change cannot occur without knowledge of what has gone before. For Fredric Jameson, one of the dangers of late capitalism is the reduction of the past to a series of stylistic effects, resulting in a lost ability to orient ourselves in time.[9] To 'know' the past and to unearth its radical contradictions is a necessary orientation for the political future.[10] In *La Jetée*, the protagonist's need to comprehend the image of the past and its contradictory meanings is necessary to his future liberation. In the film, as in a Marxist reading, we ignore the past at our peril; in Marker's version how we 'know' the past is in itself a question.

The second formulation derives from the writings of Sigmund Freud, providing a more troubled emphasis on the relations between past and present. Closer to a form of ghosting, here the past lives in the present, and lets its disruptive effects be known in the most unlikely contexts. The past, for Freud, filters the present and disrupts its forward momentum, spoiling the ideal of progress. The individual has no protection from the eruptions of the past, nor is the past stored in temporal order. The unconscious, famously, is a land without time, and so moments from the distant past may be more powerful than recent history. In *La Jetée*, the scenes of the camp where the man remembers — free-associating the dreamscape of the past without being able to control its emergence — play out the Freudian sense of the past as an unknowable landscape that cannot simply be mined by the camp doctors. We hear that 'time travel' drives some inmates in the film mad or even to their deaths. For both Freud and Marker, the present is a condition of multiple temporalities with its concomitant dangers, and pleasures, of overlap.

The past as repetition is the third conceptualisation of pastness, rooted in the idea of finite matter repeating in infinite time. The eternal recurrence, the past endlessly repeating, derives from the 'great thinkers' of repetition: Søren Kierkegaard, Friedrich Nietzsche, Martin Heidegger and, more recently, Gilles Deleuze and Giorgio Agamben. The idea of eternal recurrence reverses a commonplace meaning of repetition. Eschewing the idea of going back as the return to the identical, Agamben regards it part of a compositional technique: 'To repeat something is to make it possible anew,' he writes in the essay 'Difference and Repetition'.[11] He continues: 'Here lies the proximity of repetition and memory ... memory restores possibility

to the past.' Repetition is a going back to unfix the order of events, the meaning of happenings, to force open the past to signify differently. For within this framing of going back, it is 'we' who have changed, thus the matter of the past plays differently — it can never be a pure repetition. We might think of the moment in *La Jetée* when the woman awakes and is briefly animated — or brought to life — as a return that is not just repetition, and that exceeds the parameters of the childhood memory. But this idea speaks even more directly to the structure of the film as the re-assemblage of scraps of memory, and photographs, as a new story. Memory has a direct line into the present and the future as matter made new.

A heated fascination with the past, a malady, a lovesickness that fuels the desire to archive objects, ideas and things — these, the fourth and final framework in this list, are what fuel Derrida's ruminations in *Archive Fever*.[12] Derrida makes a return to Freud's archive, to the idea of an archive of Freud's work and life, to investigate what this desire for the past — for keepsakes, mementoes and souvenirs — may mean. In this version, the desire is not, as we may think, for preservation or mummification. Rather, in Derrida's view, the archive and all that it holds — by implication any material that records a life, an idea, a moment — is addressed to the future. The archive is both commencement and commandment, a setting of things in place under the jurisdiction of a law governing a rightful place. The 'past' made manifest is always a selection that doesn't reveal its rules. More importantly, the past is assembled and re-assembled in the present, but not for the needs of the moment. The archive is a time capsule sent into the future, addressed to a yet-to-be viewer, a correspondence from the present to the future via the past.

All four of these frameworks apply in various ways to *La Jetée* as the film draws us in to the strange relation of a fiction about time that also exists and changes in time. But the temporal registers of *La Jetée* are not simply presented as a now, then and what-is-to-come. Marker places the fulcrum of the present in the future, a future-present from which the present as it was (1962) appears as the past. In a sense, Marker manufactures Derrida's relations of the archive in this manoeuvring of syntax. The film is a view of what the present will look like from there, the future. It is, in a sense, an othering of the present, a making strange of its objects, people, thoughts and landscapes in order to bring them into view, to provide a frame through which the ineffable present may be described. Amongst the stuffed beasts and broken statues within the film is the idea that someone from the past left these things for us, 'us' as a future people constructed by their idea of who we might be and what we may desire. Similarly, *La Jetée*, a work created some 47 years ago, archived a past directed at us and other future viewers.

Modern Forms of Flight

The beginning: a man is marked by an image from his childhood that he does not know the meaning of, a marking that is bodily, like a scar, a sign that he cannot decipher. Why does this man hold onto this image like a talisman, a thing that holds his belief? The film opens onto photographs that are dream-like: an airport, children and their parents observing aeroplanes; a woman's face (figs.2 — 3).[13] The sequence is given dramatic tension by the figure of a falling man and, we are told, cries from the crowd. When the narrator tells us 'Later, he knew he had seen a man die', it is a promise that we too will come to know

the significance of the event. This vignette sets up
the enigma of the woman and of the event of death,
one seemingly full of promise and the other an ending.
The man carries both with him as his particular souvenirs
— already there is the potential for both belief and
disillusion. From here the film moves into the social
dissolution that is a result of a terrible war, imaged
as a sequence of post-apocalyptic Parisian landscapes.
The future that Marker imagines takes place in a fallen
world where life above ground is poisoned, and men
live like rats in tunnels beneath the city (figs.4 — 14).
Life in the subterranean camp is reduced to the need for
humanity to secure its survival, a project that dispenses
with individual value along the way.

The despair of this imagined present echoes what was
Marker's own recent past, World War II. The images
of Paris as broken ruins and rubble resemble photographs
taken immediately after the bombing campaigns. The
image of a church split apart and filled with debris,
for example, is set in a sequence that ends on an image
of an arch, a symbol of civic and military glory, broken
into two. The city is littered with failed beliefs. The camp
recalls previous war camps, a subject that Marker had
worked with in Alain Resnais's *Nuit et brouillard* (*Night
and Fog*, 1955), for which he was Assistant Director.[14]
The soundtrack of *La Jetée* creates an explicit link with
the Holocaust in the German voices that whisper during
the scenes of experimentation, in which camp inmates are
used to find a way out of the present predicament. The only
hope for the survival of humanity is through time, we are
told, travelling into the future to secure resources powerful
enough to regenerate the world. In the dark tunnels
beneath the city, camp doctors conduct tests on men who

retain powerful images in their minds.[15] The subjects risk suffering, madness and death, and here Marker produces haunting images of gaunt, terror-stricken faces, whilst camp doctors, clothed in protective materials, look on.

The power of images is underscored at every point. The opening line of the film spells out a key distinction: it tells a story of a man marked by an image rather than a memory. The status of the image, as dream, fantasy or memory, is uncertain, but its effect is definite. Importantly, it is the potency of this image that singles out the protagonist as a subject for experimentation; the hope of time travel and future salvation rests on the capacity of men to mentally imagine, to be affected by the image. The risk attached to time travel is ontological displacement. 'The shock would be too great' to wake into another time, to be born again as an adult. Death, photography and shock are bundled together in another place, in the writings of Walter Benjamin. To disappear into an image is to travel in time to a place that is necessarily prior. This knowledge, for Benjamin and for Marker perhaps, is present at the taking of a photograph. The instant addresses itself to the future like an electrical current that runs through the finger to the shutter and into the image. 'The camera gave the moment a posthumous shock, as it were', remarks Benjamin, drawing attention to the corporal risk attached to manipulations of time.[16]

The experiment in time travel produces suffering. Days pass as the protagonist submits to the experiment (figs.15—16). A state of pain endures until the tenth day, when 'images begin to ooze, like confessions'. It is a curious description of a flow of images as words (confessions), and implies that they were stored in a secret interior,

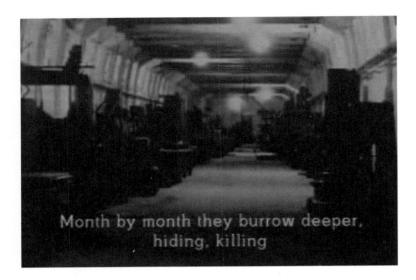

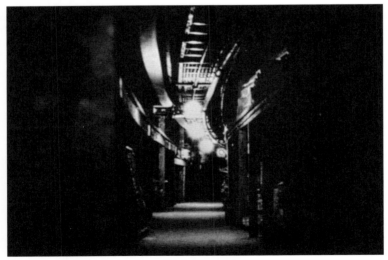

Above: Alain Resnais,
Nuit et Brouillard,
35mm black-and-white and colour
film, mono, 32min, 1960

Below: *La Jetée*,
35mm black-and-white film,
mono, 26min 37sec, 1962

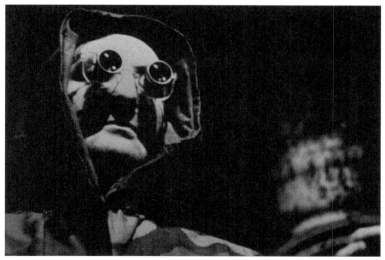

a place of yearning. The images that ooze are portraits and landscapes: a room, a child, birds in flight, a boat on a lake, a woman in a doorway, the pier at Orly, a graveyard and a rural landscape with a ruin that borrows from the romantic idea of a 'natural' erosion and decay. In the midst of this stream of images the woman appears twice: at the end of the pier and looking out from a car window. The chimerical woman is submerged by other figures and statues — fractured and chipped, headless or faceless. The attention to broken forms is insistent. We are instructed to look at the fragments that endure, at the partial nature of things that survive over time. Almost like a warning (a siren?), these images, like those of Paris in the opening sequence, speak of the incompleteness of our experience of the past. Statues and ruins, like photographs, are only part of the story. But, significantly, their partial form allows our own supplementation, our own interpretive creations, to take root.

On the thirtieth day he meets the woman. It is in a department store, in the midst of an array of displayed goods, mirrors, flower displays (fig.17). The world 'stuns him with its affluence'. Distracted by the sensory delights of surfaces and textures — glass, plastic, terry cloth — the man loses the woman. The experiment continues and they meet again, this time in the open air. Time is rendered synaesthetic, as though one could taste the 'flavour' of the moment they are living. The sensual plenitude of this past contrasts sharply with the paucity of the 'present'. They meander through a public garden, ambulatory, wandering amongst children who appear to enact the man's wonder at the scene around him. Time, the narrator tells us, is of no relevance here; it 'builds itself painlessly around them'. Yet time does enter the frame as the woman touches the

necklace around his neck, a combat necklace from the third world war. He invents an explanation, we are told, that seems to sidestep the matter. But shortly thereafter, as they look at the markings of time etched on a sequoia tree, he points to a place beyond the edge of the tree to indicate where he comes from (fig.18). And in another moment — for the film builds here an accumulation of moments without purpose or structure — he returns to this world to find the woman asleep in the sun. This scene prefigures the bedroom scene to come, the scene of awakening. But more importantly, the multi-directional force of time is made present. He knows, we are told, that in the world from which he has travelled, she is dead. It is a moment that perfectly describes the relation of the viewer to an old photograph, to a sense of pastness that spells the viewer's own mortality as well as that of the subject within the photograph.

In the midst of this world of the past that is out of time, dateless, 'without memories or plans', a warning is issued of something ahead, a barrier. Suspense enters the past, as the past is given a future, a finitude. The film returns to the camp, to the man lying in a hammock. We are aware of his ability to be in the past and the present. In one of these moments there is a curious cross-fade where the woman leans into the image from the left, whilst an image of the man's face surfaces to the right, as though she crosses into the 'present', his world of the camp (fig.19). The grace of what we might call her 'almost-presence' contrasts with the images of the camp doctors who lean over the man. The possibility of the woman's entering this world brings with it an air of intimacy, of care, a question of who is watching over whom. However, how we watch, and how we want to be watched over, become more pertinent in the

next sequence. A close shot on the face of the man, lying unconscious as he is experimented upon, is cut to black, which then gives way to a close-up of the woman's sleeping face. This in turn dissolves into another variation of the shot, as though the frame were slipping. We watch her shift slightly, raise an arm, her jaw slacken minutely, small details observed in the shift from frame to frame. The tightness of the framing emphasises intricate bodily details: the hair under her arm, her eyelashes, the shape of her mouth. This sequence of ten images plays to a soundtrack of birds noisily singing, which rises to a sonorous crescendo when the image slips into real-time (figs.20—21). The woman's eyes open, blink and stare at us. She smiles. She is looking at us with recognition. More than this, she is looking at us with the affection saved for an intimate other.

The film returns briefly to the scene of the experiment, a staging that contrasts starkly with the previous sequence. The camp doctor stands over the man, and the man looks up at the doctor fearfully. The image cuts and fades up to the past again. The man and woman meet, this time in a museum, for one of the longest sequences of the film, and in many ways its pivotal scene (figs.22—27). The idea of the museum has already surfaced earlier in the narrator's commentary, in the suggestion that the images of statues may have been 'the museum of his memory'. These are ruins of a different kind: a natural history collection of animals preserved in lifelike poses. The animals, like photographs, are without context, plucked from their natural habitats just as photographs pluck moments from time. Giraffes stare out as though across a prairie, a group of rhinoceroses stand back-to-back as though on the lookout, and cats peer out from behind glass as though caught hunting; all are

jumbled together in the space of the museum. The man and the woman look at the dead. They laugh, point, gesticulate, as though perversely animated by the lifeless animals around them. The man and woman, more so than in other sequences, are at ease together in this space, where dead things pose as if they are alive. The museum displays collections of animals and objects, perfectly preserved but with no obvious connection between the species. Some of them are extinct, others not, but all of them exude an air of exoticism, as though the past cannot help but be extraordinary.

The narrator informs us: 'The meeting at the museum had been the last.' With the success of the experiment, the man is now to be sent into the future to fulfil his mission. The final third of the film flows more uniformly forward, or maybe it is just the sense of fate that feels unremitting as the protagonist is propelled forward on a course, leading towards the pier at Orly. Travelling into the future is a more arduous task; the future is better protected. But the man travels to a new planet where Paris is rebuilt. The type of image changes from that of a conventional photograph to a more graphic representation. Detailed, grid-like images, reminiscent of microscope slides, represent the city of the future. The perspective they employ appears cartographic, the flattening of the city into a surface. Yet, on closer inspection, vein-like inscriptions in the images form a curve, suggestive of the cross section of the sequoia tree the couple looked at. We are in fact not at a distance but very close to the object. If indeed this is a sequoia tree, time is spatialised as the lines that mark the tree's annual growth become the structure of the city. It is a form of abstraction that prepares us for the images of the future that follow. The future is not a place but an

abstract arrangement of human heads, photographed against black: a dematerialised idea of existence, consisting of faces without bodies that seem to float in the frame. The use of high contrast lighting creates sharp contours of white and black, forming a pattern in which black objects attached to the foreheads of the figures become focal points.

The man recites the camp leader's request for salvation, a request that performs a tautological loop. If the people of the future have survived, their gift to humanity in fact ensures their own existence. The man is given resources powerful enough to regenerate the planet and he returns to the present, where, having performed his task, he is interred in another part of the camp. There he awaits death, with somewhere inside of him 'the memory of a twice-lived fragment of time'. In this feat of time travel, it is the repetition of the past that takes significance rather than the journey into the future. This is the fatal flaw of the protagonist, lodged 'inside' his body, as though the unforgettable image were a pathology. In this suspended state, where literally the man hangs again in a hammock, the people of the future communicate to him that he may join them in the future. But he asks instead to return to the past, to the world of his childhood and the woman (figs.28—33). The wish is granted, and the man returns to the scene at Orly Airport .

It is the warm day of the beginning of the film, with parents walking their children onto the observation pier to see the planes. The narrator tells us that the man thinks, in a rather 'dizzy' way, that the child he had been is also present. The man looks for the face of the woman. In a reversal of the first shot of the film, the sequence opens at the beginning of the pier and moves towards the end.

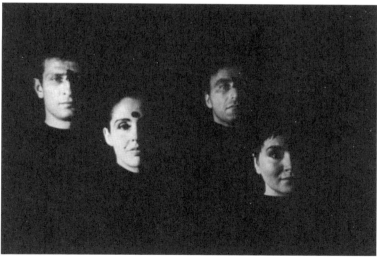

La Jetée,
35mm black-and-white film,
mono, 26min 37sec, 1962

The camera moves to the front, to the left and behind
the man as he begins to run (figs.34 – 35); close images
of the woman's face intercut his movement. The soundtrack
mixes the noises of announcements and jet engines, a rising
sound that finally gives way to choral music.[17] The woman
waits at the end of the pier, while to the left of the frame
is one of the camp doctors, recognisable by the strange
optical device he is wearing. As the man runs he notices
the figure turned towards him with what appears to be
a gun. The moment of recognition brings the final compre-
hension: 'there was no way to escape Time'. The man
falls, the woman repeats her gesture of shock and the
film closes on an image of his lifeless body (figs.36 – 37).[18]
The man's fate is sealed in this twice-lived moment, but so,
too, is ours, for we also have been here before.

Photography after History

In a short piece of writing to accompany the digital release
of *La Jetée* in 2003, Marker gives us a memory, a recollec-
tion of his first attempt at making a film. Inspired as a
boy by a hand-wound projecting box, a Patheorama, he drew
a series of pictures of his cat, glued them together and added
captions. As he scrolled the images along, 'all of a sudden,
the cat belonged to the same universe as the characters
in *Ben Hur* or *Napoleon*. I had gone through the looking
glass.'[19] Cinema is at once more complex and more simple
than previously imagined. It may be resourced by a
complex array of materials, but it can also be reduced to
the simple movement of frames through a gate. 'Thirty
years passed. Then I made *La Jetée*,' he writes, as though
this childhood image took its own time of return. Marker's
fondness for composing film from bits and pieces, material
gleaned from unassuming aspects of everyday life, can
be glimpsed in the intervening period in his documentary

projects. Cartoons, drawings, posters, maps, advertisements, poems, archive footage, paintings and engravings are used, pasted in, mixed up and drawn into some sort of narration. In what appears to be a highly idiosyncratic practice, Marker also incorporates various art movements that pre-date him: the political photomontage of the 1930s, Dadaist cut-ups, Surrealist juxtaposition and the Lettriste passion for writing systems.

Going through the looking glass is to enter a place of different scales and where time may run backwards as well as forwards. Yet there is something else here to do with frames. The looking glass is, after all, a mirror, a framing device, and in *La Jetée* we are given the opportunity of viewing photography through the frame of cinema. Conversely, and fittingly for the reflective symmetry of the mirror, we also get to see cinema through the frame of photography. In abandoning the search for medium specificity, Philippe Dubois writes of the advantages of framing through another: we 'have never been in a better position to approach a given visual medium by imagining it in light of another, through another, in another, by another, or like another'.[20] As Dubois notes, Marker's film is exemplary in this practice. Photography, viewed through cinema, becomes a strange 'pass-time', detached from the mores of amateur and professional codes of practice, as well as from Roland Barthes's ruminations on its essential features and his preference for the photograph over cinema. Comparable to André Bazin's idea of cinema, Barthes's conception of photography saw in the photographic record an inscription of time, a mark of mortality and simultaneously a defence against it.[21] Marker drives us in the opposite direction.

With not exactly an indifference towards what the images mean, Marker takes photographs and uses what is within them to create a fictional frame in which each photograph comes to signify anew. There are many types of photography used in *La Jetée*, and some appear to be found images, images detached from any authorship, or any particular place or time. Released from any sense of an 'original' context, the photographs appear to float before us, remnants of another time but exactly which time is not clear. A woman standing next to a window stares back at us, two cats look up from a bed, a portrait of a straw-haired girl who looks unsmilingly at something out of frame. The otherwise eclectic range of images is gathered under a rubric of 'before' the fall. Peacetime is a place where light is honeyed, where the detail of things is revealed in crystalline focus, and people, things and landscapes have the bearing of a profound poise and calmness. The images contrast sharply with the dark sequences of the camp, artificially lit to emphasise the harshness of conditions, and captured in grainy indistinct images that show their subjects to be off-centre, unbalanced. Yet it is possible (though unlikely) that these different images were shot on the same day. Only through the frame of the story are they put into a context or a narrative, that is, into the time of fiction.

In Marker's hands, photographs are not time's loyal witnesses but tricksters of temporal consciousness. This inversion of the role of photographs finds support from the Czech philosopher Vilém Flusser, who regards photographs as post-historical. In Flusser's universe, photographs 'are dams placed in the way of the stream of history, jamming historical happenings'.[22] This is a philosophy that distinguishes image-thinking from writing-thinking.

Photographs are part of a tradition of image-thinking that resists the constraints of the written text, its tenses, its forward movement and its regimentation of reading from left to right. Photographs retain some of the magical consciousness of pre-historic images that offered a subjective world view. It is magical because the environment was drawn as a scene of reciprocal relations, of affective ties that the painter imagined and drew, and magical again because the environment was then experienced as a function of the image. The magical image brings a vibrating, singing landscape to life; thus images are part of a way of inhabiting the world as a consciousness enchanted. Flusser situates photography within this tradition that pre-dates the photographic image and its referent of the 'real' world. Photographs, for Flusser, were invented to bring the magical ahistorical image back, to overturn the rule of linear writing. Whilst there are demands made on photographs to serve the written text, to be either illustrative or evidential, photographs ultimately float free of these impositions. They belong neither to a time nor a place, but to a way of imagining and making the world as a scene, a range of different textures, memories and fantasies that resist temporal classification.[23]

Photographs in his account are the rebellious tokens of this experience: 'structurally speaking', writes Flusser, photographs are 'antihistorical'.[24] There are too many photographs to neatly line up to provide one account, and in their multiplicity they produce contradiction rather than evidence. The thickening accumulation of photographs recalls an earlier version of photography in the work of cultural critic Siegfried Kracauer, writing in Berlin in the 1920s. Images swirling out of time produce a

snowstorm that coats the world rather than illuminates it: 'The blizzard of photographs betrays an indifference toward what the things mean.'[25] For Kracauer, this storm of images released from any historical context was an ominous sign of the capitalist abstraction of things from their sources, of signs from meaning. For Flusser, on the contrary, it is wholly positive. The swirl of lost-and-found and proliferating photographs liberates the images from the task of re-describing the world. Instead they re-imagine it, and it becomes possible to think that the environment may function as a result of images rather than vice versa. Photographs, for Flusser, are the virtual possibilities of a future. Marker, we might say, is involved in the same project. The photographs of *La Jetée* suggest a historical consciousness potentially torn from its roots. The imposition of a past, present and future tense on a range of disparate photographs reveals two things: that the photograph will lend itself to the spoken word and obey an order, and also that the photograph is pliable, lending itself to many different positions in many stories without *belonging* to any one.

In our attention to Flusser's ideas on photography, we are assuming that photographs are uniform, whereas a closer viewing reveals differences between the types of images in *La Jetée*. In the first instance, there are photographs that function in the traditional genres of still photography: still life, portraits and landscapes. The sequence of images that, approximately ten minutes into the film, bursts like a dream from the past is made up of these conventionally composed shots. There is a sobriety to these pictures of scenes, animals and people; the subjects are accorded full attention by the camera. The peacetime bedroom with its dishevelled bed and drawn-back chair is photographed as

though someone has just left the room. Arranged as a classical composition, it is backlit with varying degrees of light falling across surfaces and objects, and given perspective and dimension. The landscape of animals grazing in a field takes in the detail of the horns of the goats, the leaves of the tree as they catch the light, the shadows cast by a low sun. And where does it come from, this image of a man in a boat silhouetted against a misty expanse of water and low hills, and the serene neatly arranged graveyard? Landscapes, unlike interiors and portraits, appear timeless, as images that could be part of radically diverse sequences, from a personal collection to a commercial calendar to a travel brochure. These images lend themselves to the swarming possibilities of Kracauer's snowstorm.

But to attend to the specifics, there are two portraits that stand out: a close shot of a small girl and an image of a woman in a room. The girl looks off to her left, as though there is something or someone that she has to pay attention to out of frame. That we are denied the information of a larger frame, and the object of the child's attention, creates an eerie atmosphere. In a similarly uncanny image, the woman standing by a window stares straight into the lens, unsmiling, as though she is presenting herself for a formal occasion, but we cannot tell. The photograph, at first glance, is notable as a perfect illustration of photographic lighting. The light creates three distinct stripes moving from the daylight of the window or the door on her left, to a middle stripe of grey behind the woman and a black stripe to her right. The narration overlays the image with a description: 'A face of happiness, though different'. What we see is not joy but a penetrating stare. There is discrepancy between what we see and what

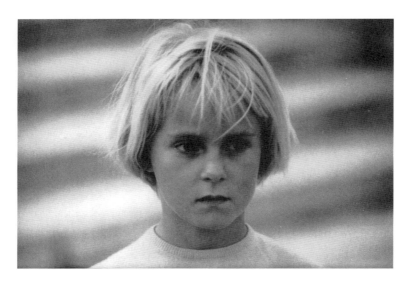

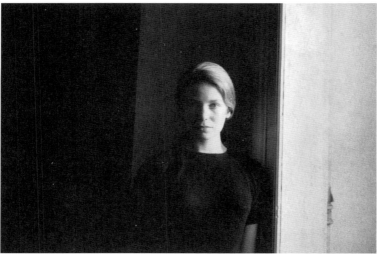

La Jetée,
35mm black-and-white film,
mono, 26min 37sec, 1962

we hear. The narration threatens to peel away from the images, as though the photographs contain a secret that is not to be revealed, casting doubt on the narrator's integrity. We are left to wonder, is this a calculated ambiguity? Photographs from the past swarm, but what can be known of them as documents of a particular moment, as parts of a story of their time, is negligible.

If these images draw on standard categories of still photography, Marker also uses a second set of photographic conventions drawn from film. Most notably he deploys the reactive convention of shot-reverse-shot. It is a photography of dramatic action that generates a dynamic relation between images, that suggests reflexive relations between stills and in fact suggests movement. This is the style used in the scenes where we would expect it, in the action sequences. On the pier, in the experiments of the camp and in the growing relationship of the man and woman as they move through the park and the museum, the camera provides a point and counterpoint. The photography here works along a different axis than it does in the landscape and portraits, which both support a dimension of time suspended and spatialised. In contrast, the dramatic sequences operate along an axis of temporal movement. Time as line, rather than the space of tableau, is given priority. It is as though there are action-images and time-images in the stills.

Yet everything is subject to a reversal in Marker's hands. Just as the portrait of the woman bridles, threatens to break out into other stories, so the dramatic sequences threaten the rules of drama: at certain charged moments they appear to suspend time. This occurs when the shot breaks out of a pattern of exchange and sinks into a

circular movement. In the sequence of the first
experiment, the camera moves initially from the doctor
to the man in the hammock in an expected exchange
of looks. But the camera subsequently seems to become
distracted by the subject of the man. In its sudden
fascination, the camera circles, moving behind the
man's head, to the side, to the front in a low shot,
opening up the scene to a sculptural spatialisation.
The line of dramatic action pleats, concertinas into
a number of possible perspectives of this one moment.
The camera, with each snap of the shutter, makes its
own voyage around the action.

This shift in tempo appears in many sequences, often
at the heart of the action. In the park, the camera is
initially in front of the pair as they walk, and then
it is behind them, to the side and lower from the front.
In the most dramatic of sequences, the final denouement
on the pier, the man rushes towards the woman. The
pier stretches out in a straight line, with no detours
and no distractions, except for the camp guard who is
not visible until it is too late. Formally, we are placed
at the end of the pier with the woman, facing the man
as he begins to run. But in this point of heightened
dramatic action, where we are anticipating the final
moment as we rush towards it, the camera shifts position.
We are in front of the man, to the side and then behind
him, the dramatic moment extended into a potentially
infinite series of moments. The woman at the end of
the pier waits, locked in her suspense just as the viewer
is suspended. The sequence moves from a human-centred
perspective (from the point of view of the woman), to
a position that is mobile, firing off a staccato round of
shots. There is drama and there is the suspense of drama,

as time eddies around the figure of the man, and defies
the direct course of action.

Properties of Scale and Duration

Back through the looking glass, we are faced with
another type of imaging. In the transition into the zone
of the future, we are moved into and through a number
of images that are patterned, abstract surfaces. The first
of these is an expanse of fragile vein-like lines, like the
skeleton of a leaf, or perhaps the texture of the sequoia
tree. Moving through the centre of the image we travel
into an image of circular shapes that seem to be liquid
bubbles. Maybe the image is a composite of different
surface patterns. We disappear into the bubbles and another
detailed image rises up towards us, a more symmetrical
pattern that appears to be a circuit board. Travelling
into the future is frequently imagined as a journey into
outer space, but here we are taken into the barely visible
detail of electronic life in close-up. In place of an image
of the earth from outer space, Marker takes us in the
opposite direction, into the minutiae of the world's
matter, deploying a type of photography used extensively
in science. As an image type, it appears non-representational
— a pattern rather than a form. It suggests a world that
exists in detail beyond our comprehension, and beyond our
powers of summonsing it through the human eye alone.
To direct thoughts towards the future is one act, to imagine
the future requires a change of dimension and perspective.
It demands that we enter a different frame.[26]

The grip that *La Jetée* has on us is in imagining one thing
through another. There is no immediate access to things,
either the past through photographs or the future through
science. Perception is always mediated, framed or set up,

and with Marker, the frame is always an unexpected
thing, like an old object found in the back of a cupboard.
So in his idea of the future, Marker approaches it
(frames it) through the skeleton of a leaf or the etching
of tree bark. But this mediated way of seeing is not of the
order of revelation. Its effect is not to disclose the secret
qualities of things but, on the contrary, to spin a web
of correspondences, to show us all of the connections and
likenesses and differences of things. This is not a film
disclosing something 'about' photography or its ontology,
but a *photo-roman* that shows us photography through the
frame of cinema. In so doing, we are exposed to qualities
of movement and stillness that in belonging to each,
belong differently.

In the scene of the woman's awakening, we are faced with
a sequence in which animation builds in the shifts from
photograph to photograph. Victor Burgin describes this
sequence in which her lips part as a prefiguring of that
in which her eyes open. 'An opening of the body, a breath,
perhaps a word,' he writes of the building stills, and 'then
vision' as the sequence slips into 'real time' movement.[27]
Burgin is speaking about the woman within the image
when he continues: it 'is as though the moment of waking
recognition has been unconsciously anticipated'. But this
comment applies to us also, for we have anticipated and
hoped for her awakening, for cinema to bring her to life
with a kiss. It is a fairy-tale prince kissing the sleeping
princess, but it is also a plane rushing along a runway,
towards that moment of flight.[28] We watch as the sequence
demonstrates the journey from stillness to movement,
but in so doing it almost erases the boundary between these
terms. When is the now, this moment when we are woken
up, set into motion, launched into flight? When the short

sequence of movement occurs, the camera isn't rushing
forward at all but holding still, as though we may discern
the shift from stillness to movement all the more clearly.
Yet the woman only blinks. Through this transition
into motion, we find conversely a quality of stillness,
and duration, of time as qualitatively experienced rather
than measured.

Through what Philippe Dubois would call the side door
of cinema, we get behind the screen to see what is screened
off from us: cinema becomes photographic and photography
cinematic. As Dubois asks, 'is the film frame (*photogramme*)
not somewhere near the heart of the fold, in other words
before an "un-nameable" object that is simultaneously
beyond photography and before cinema, more than the one
and less than the other, while being a little of both at the
same time'?[29] In this fold in which the image is more
than one (photography) and less than the other (cinema),
one can find ribbons of Deleuzian thought about time and
movement. In Deleuze's schematic reading, which draws
heavily on Henri Bergson's studies of time and motion,
cinema is in two parts: the movement-image and the
time-image.[30] The affective imprint of cinema is not
from its enchantment through moving images, but in
its presentation of time. Cinema gives us time as duration;
a film is not experienced as a unit running in 'real-time'
as we sit through it, watching at 24 frames per second.
When we enter the dark space of the auditorium, we expect
to encounter worlds of different durations, where time
can be stretched like elastic, contracted or even still.
Marker knows this, and he shows us by placing movement
and stillness where we would least expect to find them:
stillness at the heart of a moving-image sequence,
and movement within the still frames of photography.

The stillness of the woman's look in the moving sequence fascinates me. But it is a fascination with qualities of movement in the still image that has struck others, and that has contributed to the influence *La Jetée* has had for a generation of artists. In John Baldessari's practice, for example, the film is constituted in the field of the spectator, relying on the viewing subject to create the connections between still images. The spectator performs the sequencing of the images, just as a viewer moving through a gallery of paintings performs a type of narrative through an ambulatory montage. Exactly what is still and what is moving is not immediately apparent, and this can be traced through Marker's film as an uncertainty of where movement and stillness begin and end. The apparently still image hops in the gate of a film projector, and the rostrum camera skims across the surface of a still image, bringing movement.[31] This uncertainty about where and how stillness and movement are manifest in an image is perhaps an influence in the work of David Claerbout. In the video installation *Kindergarten Antonio Sant'Elia, 1932* (1998), Claerbout takes a photograph from 1932 of school children at their desks, with a window on their right looking out onto two trees. It appears to be a typical archival image, yet if the viewer watches attentively (that is, if the viewer is still for long enough in front of the image), she will see that the leaves on the trees are moving. Marker's influence might similarly be seen in the photography of Jeff Wall, who transliterates the cinematographic process into the still image.

What is the time of the image? Is it the moment of taking, or the distance between the taking and the looking, or a more variable and complex phenomenon that may itself change in time? In *La Jetée*, Marker mixes up the time

of the image, but he imposes a strict duration on our
looking through the measured rhythms of editing.
We are allowed to look for so long, and the images we are
allowed to look at for longer than others are chosen for
us. The first sequence, for example, forces us to linger
on the face of the woman whilst the other images in
the sequence tick by. Marker projects a longing into his
viewers in this moment of lingering, so that we too must
find her intriguing. In attending to various durations
of the image, *La Jetée* opens out the possible times of the
image and shows us how this is hinged to looking. Allowed
to look for longer, we seem to look further, to become more
involved. But can this effect be dispelled, and if so, how
long is too long? These concerns are given play in the
work of a number of artists, most notably Douglas Gordon.
In slowing Hitchcock's film *Psycho* (1960), Gordon creates
a new duration for the image, suspending movement to
a fraction of its former speed. The time of the image in
24-Hour Psycho (1993) invites a different type of looking,
in which details formerly passed over are revealed, and
the eye performs a different set of operations across the
surface of the film.[32] Or rather, the eye is engaged in
a form of movement that the cinematic usually reserves
as its own privilege. Stillness or slowness of the image
facilitates movement elsewhere.

Assemblage
'Cinema was looking for one thing, montage, and this
was the thing twentieth-century man so terribly needed',
wrote Serge Daney.[33] Although Daney was writing with
Jean-Luc Godard in mind, we could claim the twentieth
century also needed Chris Marker and his skills of assem-
bling the visual.[34] Another way of thinking about *La Jetée*,
other than as a film made mostly of stills, is as a project

that draws attention to the relation between images. In this sense, it is a work of post-production.[35] The meaning of an image lies not squarely within the frame, but in its relation to other images and sounds. 'It was made like a piece of automatic writing,' Marker has recalled of the process of making the film. 'It was in the editing that the pieces of the puzzle came together, and it wasn't me who designed the puzzle.'[36] It is difficult to imagine the making of this film with its famously taut narrative as a puzzle that 'came together' in the editing, yet the intuitive sense of connecting images lies in the details of the way images are joined and in the rhythm of moving through them.

There are three editing practices connecting images in the film. First is a series of dissolves and cross-fades. The second is a joining of stills back to back, or what might for convenience be called a hard cut. Third is the use of black leader between images. The use of dissolves and fades is reserved for certain sequences: the images of Paris, the stream of images of 'the past' during the first experiment and the scene of the woman's wakening.[37] Scattered through the film at moments of transition (between time zones), softening the hard edges of separate spaces, the dissolve has more than one effect. On the one hand, the dissolve produces a lyricism through a sink *into* the photograph and through it to another, rather than moving *on* from the image. In the first sequence of recall, the images of the peacetime bedroom, the animals grazing, the woman walking in a field have no obvious connection except for their pastness. This is underscored by the visual technique of the dissolve through which we are allowed to fall into the image. The effect is to establish an equivalence of feeling across the images whose edges are blurred in the

dissolves. Some read this as a type of entropy, a disintegration of energy when the image cannot move forward but appears to lose its form.[38]

On the other hand, the dissolves work to bring one world into another, a layering that speaks of time frames as simultaneously occurring, or co-existing. An image bleeds through the surface of another, suggesting an uncanny co-presence that won't fade, like the man whose face we see several times in the underground camp. We are told he has been the subject of experimentation. We see his gaunt face and terrified stare several times before it is cross-dissolved over another image, seeming to hover, to remain beyond its term. The ghostly image flies in the face of the narrator's concise delivery of information. And against the rhythmic clicking-past of the back-to-back images, the dissolve gums up the system, images seem to stick together, refusing to pass through. Marker uses the cross-dissolves with the technique of repetition, so that we experience not only a stickiness, a change of rhythm, but a return. Images pass in time, as it were, but they also come back. In the underground camp sequence, the corridor is a peculiarly evocative image used repeatedly. The action moves forward, still follows still, the corridor appears once and is gone. It appears again and disappears just as swiftly. By the third and fourth reappearance, it is refusing a clean break, refusing to leave. It sticks, it fades and eventually dissolves.

The curious combination of repetition and fade brings to mind Giorgio Agamben's thoughts on editing. Stoppage and repetition, for Agamben, are the defining characteristics of montage. In a reversal of the concept of continuity editing, stoppage puts a halt to the forward run of the dramatic, and has the power of recall. An image brought back to us

is not a means to an end in a purposeful drama, but a
sign of the power of images, themselves, to communicate.
Here is the corridor; we have been here before. The perspec-
tive of the photograph leads the eye into the image — an
invitation to follow the path that stretches out and curves
away to the right. We cannot see what is ahead. The over-
head lamps burn with a starkness that fails to illuminate
the tunnel's spaces and shadowed cavities to the side of
the path. On both sides of the path are box-like wooden
constructions reminiscent of the temporary structure
of World War I trenches. They suggest an idea of collection
and classification of things. Overhead and running
alongside the lights are lines of pipes and metal grills
exerting the pressure of an industrial past. The image
returns and brings with it these various moments.
Belonging to none exclusively, it echoes multiple moments
of twentieth-century history, but also the multiple times
of our own encounter with it.

The image appears five times in the first sequence of
the camp. Its first association is with the experimenters,
and their line of pursuit. The corridor subsequently
becomes situated between images of the haunted subjects
of the experiments. By the third viewing a man's gaunt
face dissolves onto the image in a cross-fade. In this
movement there appears to be resignation as we sink back
into the confines of the enclosure once again. The image
appears a fourth time, and in this instance it cross-fades
into the protagonist in a hammock, prepared for the next
experiment. The possibility builds, appearing to move
forward, gathering a momentum of some sort. Now that
we are tempted by the possibility of movement and flight,
the image of the corridor taunts, seems to mimic stasis
and confinement. There is now an expectation on the part

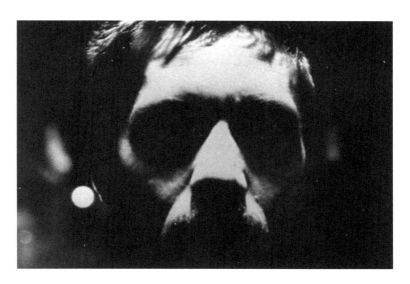

La Jetée,
35mm black-and-white film,
mono, 26min 37sec, 1962

of the viewer that the corridor may lead somewhere, a way out of this suffering and this recorded moment in time. Yet the image presents a paradox, that, seemingly, when the protagonist returns to the same place, and we return to the same image, something will have changed. But nothing about the image has changed. Except, that is, its order in a sequence, its familiarity and its relation to the viewer. Actually, everything here has changed. The corridor as an image is no longer new to the viewer, and its accumulating meaning vibrates with every repeated viewing.[39] Repetition in montage is return, and as Agamben would have it, to go back is to 'restore possibility to the past'.[40]

It is important to pay attention to Marker's use of rhythm here, for the return is made explicit through a building of momentum followed by stasis. In the scene of the experiment on the protagonist, an illustration of the second of the film's editing techniques, the images gather force, cutting between shots of the doctor in shadow, the needle in close-up, the man's arm, the man's face, the needle puncturing skin. And then a close-up of his face, with his eyes covered, dissolves. The dissolve breaks the rhythm of action and delivers us to a different state where our consciousness is closer to that of the man. We are invited into a bodily space of feeling rather than an observational position, looking on with the commanders of the camp. The shift of sensibility worked by the rhythm and the dissolve is no small feat if we consider for a moment the contents of the image. The shot is a close-up of the man's face. His eyes are covered with pieces of sponge fabric, some wire and sticking tape. We realise with this shot that technologies of the future-present are not sophisticated. Yet the force of the staging, which also prefigures

the scene of the bedroom in reverse (the woman wakes whilst he is put to sleep), delivers us to a place of connection. This is a critical shift of relation as we prepare to go with him on this journey. The following images rise in pace again; we see him suffer. The images are reminiscent of Francis Bacon's tortured figures, his heads that seem reduced to mouths. The man bites the fabric of the hammock, his face upturned in anguish.[41] And then again a dissolve, this time to black, fading into a different state of consciousness and a different temporal zone.

The third editing technique in the film is the use of black leader. 'Out of the two hours you spend in a movie theatre,' states Marker, 'you spend one of them in the dark. It's this nocturnal portion that stays with us, that fixes our memory of a film.'[42] Whilst our experience of cinema at 24 frames per second naturalises the absence of image between frames, Marker draws out the possible meanings of the black screen.[43] Towards the beginning of *La Jetée*, we are placed in the dark for an extended duration of ten seconds. We are only four minutes into the film. We have watched the scene at Orly Airport, and the images of a ruined, post-apocalyptic city. And then we are in the dark with only a voice. The function of this absence of image is various: to leave a reverent pause to acknowledge the suffering of the war, to create a qualitative space between the apocalypse and what followed, to mark the prologue from the main body of the film. But the effect, above all, is to make an audience aware of its own presence as a collective body, and to make an audience listen. The omnipresent voice of the narrator informs us of the course of events. With no distractions, nowhere else to go, we have to pay attention in this 'nocturnal' state that, according to Marker, is the state that stays with us after the film.

To throw an audience into darkness is one of the most powerful, and possibly sadistic, things a film-maker can do. Like small children, we have to wait and listen. We are perhaps being prepared in this visual interval for the rough treatment that the man is about to receive at the hands of the camp doctors, and this, after all, is a dark place. We are suspended in darkness as he is about to be suspended in time waiting for events to happen to him. This suspension of the image is not a singular event, but a warning to pay attention to how images are joined, and to the gaps that such joinings cover over. Black leader alerts us to the practice of editing as selective, producing absences as well as the presence of the image. There is a corollary of editing and memory at work here; as Jean-Louis Schefer points out, this deployment of leader 'replicates gaps in recollection', and produces a space for fantasy to take root.[44]

Animation

'Tête Apôtre' ('head of the apostle'). The words are hand painted onto a rock or piece of wood somewhere along the corridor. The image appears twice, first cut in amongst shots of the men who have suffered at the hands of the camp guards, and second between images of the protagonist as he is prepared for experimentation. The idea that these subjects are ambassadors travelling through time with a mission or a lesson supports the story we are listening to. The image curiously sends us back in another direction, towards the origins of cinema in animation: *El Apóstol*, the oldest animated film in the history of cinema. Whether or not Marker knew of this film or whether it is a coincidental crossing, it provides a convergence of his preoccupations. Made in Argentina in 1917, the film ran to 70 minutes with 58,000 frames.[45] This ambassador

of time, however, no longer travels, as the film was lost or destroyed.

Animation is the illusion of movement. When it is hand-drawn, it appears charming in its naïveté, and when it is photographic, it appears to be the stuff of magic. Early cinema, as many have noted, had a fascination with bringing bodies or spirits back to life. Animation offers resuscitation, and in this it is the foundation of cinema's activity. But it also crosses categories. If cinema crosses categories of time — mixing the past into the present as it hurtles into the future — animation breathes life into what we have taken to be dead. In *La Jetée*, there are, between these poles of life and death, various gradations of being: a look back at two key scenes suggests the intimate connection between ethical relating and remembering. The first scene has the woman appear over the image of the man in the hammock; she hovers like a ghost, but also as a figure that has come to collect him, as though she may animate the man. The sequence has already begun by mixing the present with the past, moving between images of the protagonist in his hammock and the woman looking back from various places in the park. And then her image is superimposed as she leans towards him, her face cross-fading with his figure lying in the hammock. For a moment she is suspended above him, watching whilst he sleeps, a cinematic trick that literalises the ethics of care, of the face-to-face encounter.[46] But the positions of sleeping and watching are about to be reversed in the following sequence.

Circling back to the moment I'll now call animation, we are once again in a bedroom, this time *watching over* the subject. On the fourth shot, the camera moves closer

still. The soundtrack plays a chorus of bird noise that ascends in volume as the images play on, fading into one another. To watch someone sleep, it suddenly seems, is one of the most intimate acts. To watch over, or simply to watch, to observe, to be in the presence of one for whom we are not fully present, appears a profound undertaking. Perhaps in this moment we are placed in an ethical relation, something like a duty of care. In the next image her arm has moved slightly; in the next her jaw drops almost imperceptibly, and now the angle of her face has turned by a few millimetres. The cross-faded images make us attentive, alive to these small details.

The woman tightly framed is a bird, caged by the camera and preserved through the chemical alchemy of cinema. She is momentarily caught, fixed — or maybe it is us who are in the aviary, the noisy industrious crowd on our cinematic perches? But there is no room for manoeuvre and draw-back because we are close upon her, this woman with her head on a pillow. Her eyes open and close and open, and she looks surprised by what she sees. [47] The experience of the unexpected hovers between her and us: she offers the smile of an intimate recognition, and we in turn mimic her. In this moment she has us in her grip. The moment breaks with the concealed fiction that we are only watching film, and in the intimacy of Marker's deconstructive moment, we are drawn into the film; we are the lover and she the beloved. In this mixed-up space of non-fictional pretending what does it mean to watch someone, an other, in this moment of privacy, and what kind of ethical relating does cinema allow us to practice? As the film shifts into movement, the stakes seem higher, the question of relation more tense. The moment belongs to Agamben's understanding of cinema

as stoppage, when the image hovers in a zone of undecidability between fact and fiction, the real and the imaginary, the living and the dead. In this sequence we are caught between a presence that is nonetheless in the past, an intimacy that is also addressed to a collective audience. And there is also the sense of an actress years ago, addressing herself to future audiences, to others she will never know.

The Gesture

We come to know the woman through her hands. Constantly gesticulating, her hands refer us back to her body. In the first image that we have of her on the pier, her right hand is raised to her mouth, her index finger curled above her lip in a question mark. Quizzical, uncertain, the woman points to herself and her lack of knowledge. Described by some as a sphinx — woman as riddle — her gestures relate a different story.[48] The woman is caught in this riddle that seems to encompass her but which she cannot fathom. Full fathom five, she is pulled down, sunk in an event beyond her. In the third image both hands are raised to her face in a show of horror, of disbelief. In the scene of the first sighting, in the department store, her left hand is raised in front of her face as she looks into a mirror. She does not want to see herself or does not want to be seen. Her hands do not so much obfuscate her expression as stand in place of it, and mediate it. In the park she is more relaxed. Walking with her hands behind her back, the slim curve of her body articulating her ease, her gestures turn away from herself and towards others. Her hand reaches out for his ID tags. Her hand points up at the sequoia tree. As she leans against a different tree, her left hand reaches around her neck. She holds onto herself because she cannot hold onto the man who may

only be her ghost. Her hand perhaps resists the temptation to reach out by folding back around her body. We could go on like this, on countless walks, watching the woman and her gestures.

In another essay that Agamben has written about film, 'Notes on Gesture' (1992), the seam between an ethical philosophy and cinematic practice is approached once again.[49] The gesture, writes Agamben, is a lost language of the body, of the body's willingness to communicate to the other. Early cinema reinvigorated the gesture after a period in which the language of the body had suffered a repression in the bourgeois stabilisation of manners and reliance on linguistic performance. The displacement of communication from the body to linguistic exchange in Agamben's reading renders physical communication invisible, swallowed up and contained in verbal communication, a pragmatic exchange. Language, it is implied, becomes a means to an end. The gestural forms of silent cinema turned this on its head, or rather turned it not only on its head but down through the body in the relishing of gestural language for its own sake.[50] Silent film raised the spectre of the gesture long after its death. The cinema, for Agamben, is not primarily movement but *within* movement, the force and detail of the gestural body thrown into relief. In *La Jetée* there is an affinity with early cinema as the words are not spoken by the actors but narrated by an authoritative voice set apart from the image. Within these mute, still images, the gesture returns with the full impact of the fixed frame, caught, frozen.[51]

Famously, Roberto Rossellini said that he would make a whole film for the sake of a gesture.[52] And like Rossellini, Marker wields a counter-force to this bodily display of

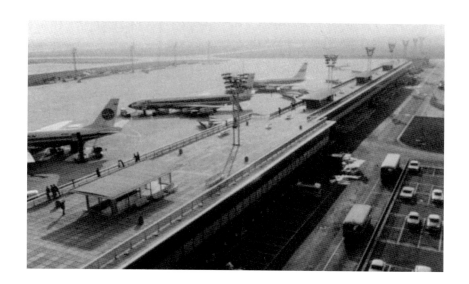

1—37. *La Jetée*,
35mm black-and-white film,
mono, 26min 37sec, 1962

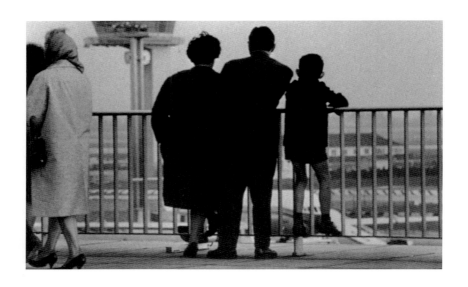

2.

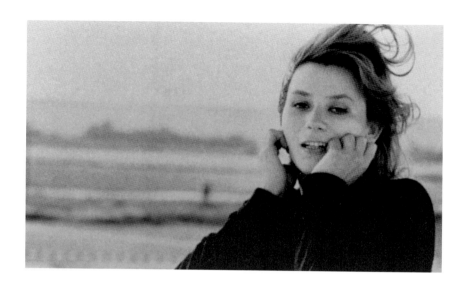

3.

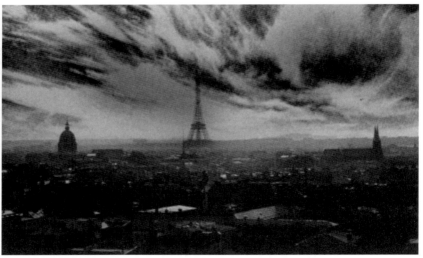

4 — 5.

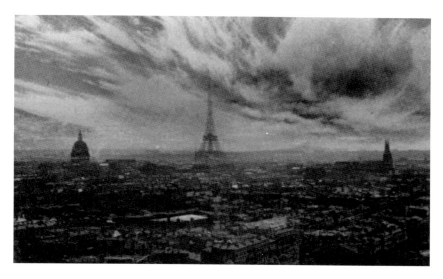

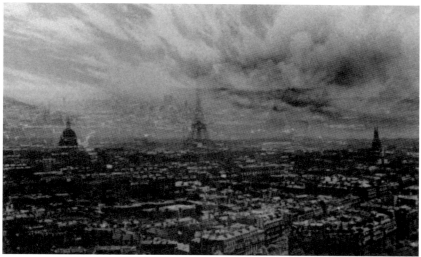

6—7.

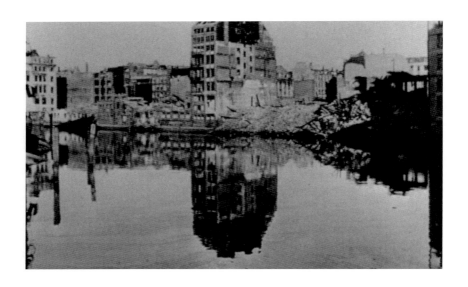

8.

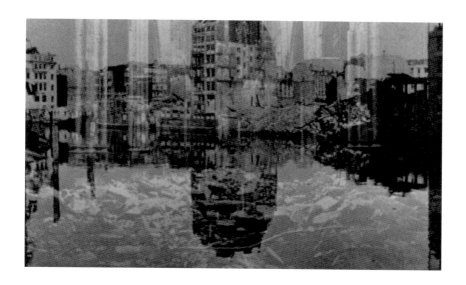

9.

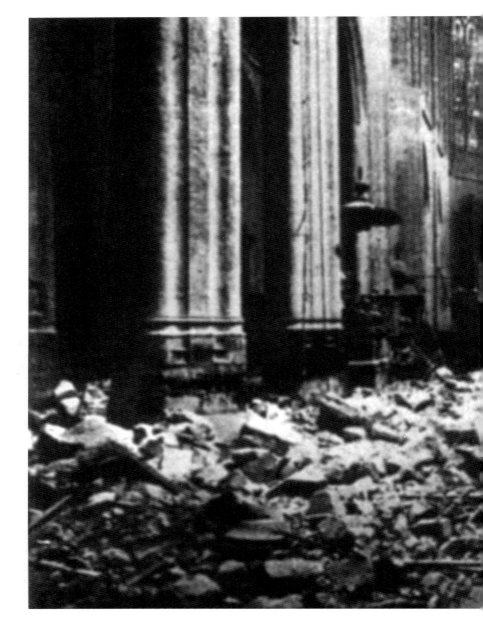

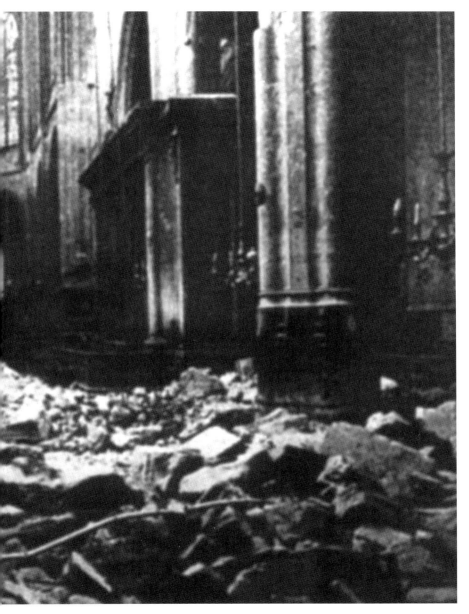

10.

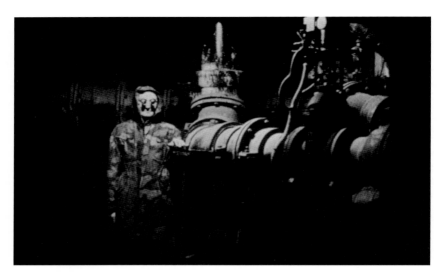

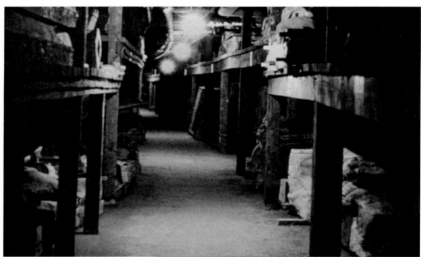

11—12.

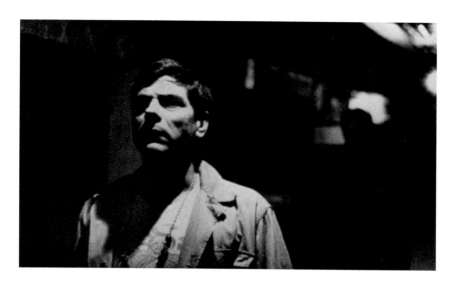

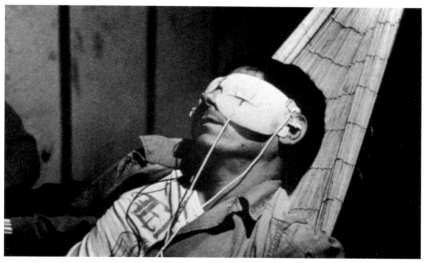

13—14.

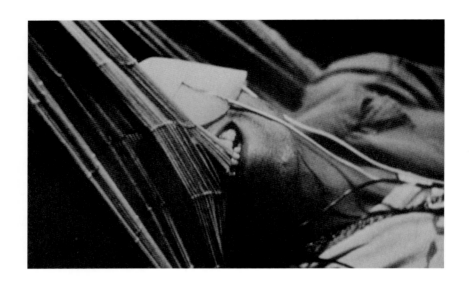

15.

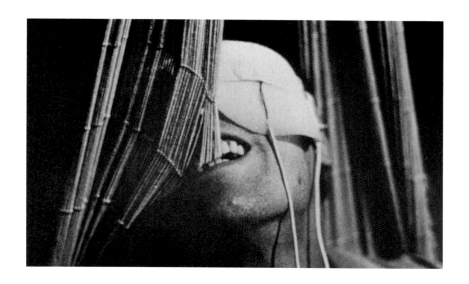

16.

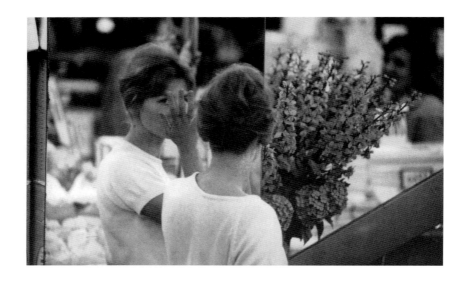

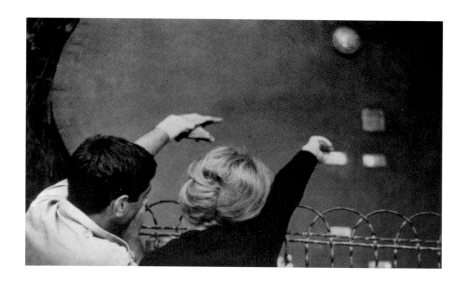

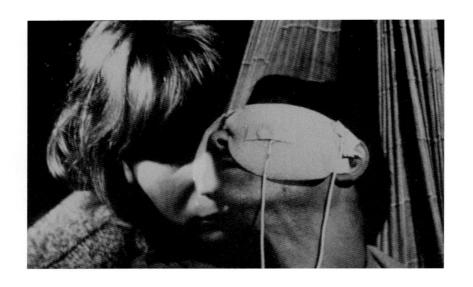

19.

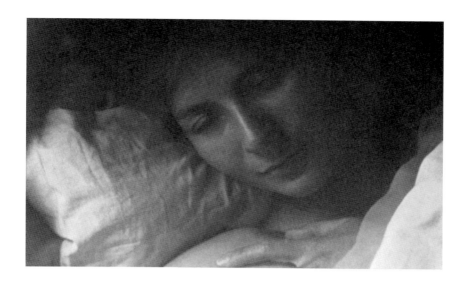

20.

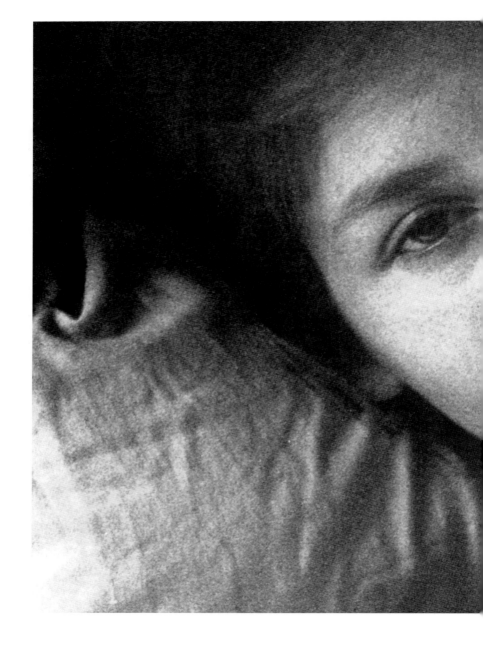

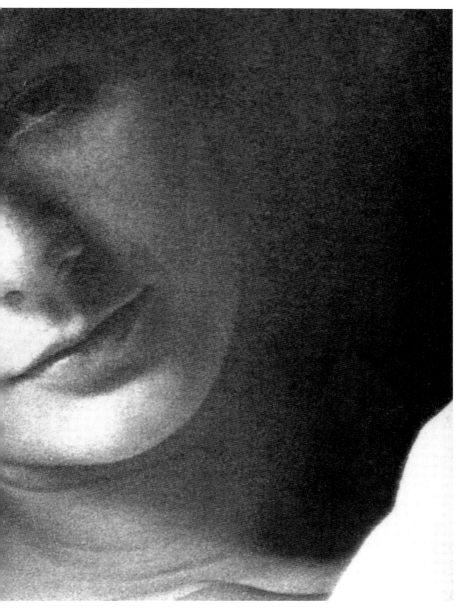

21.

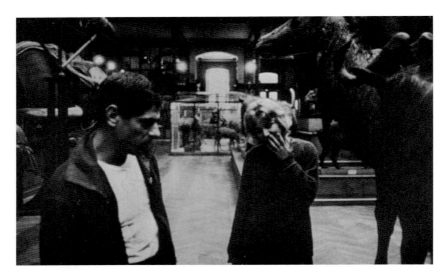

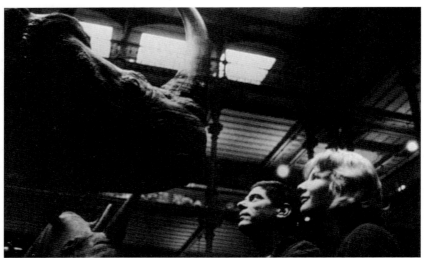

22—23.

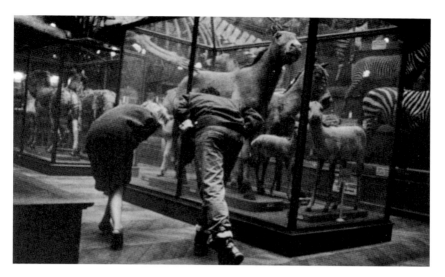

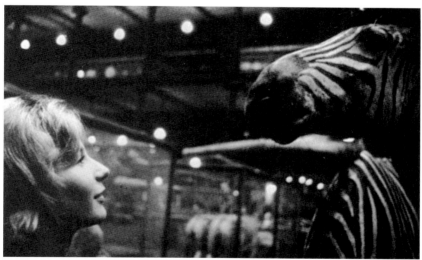

24—25.

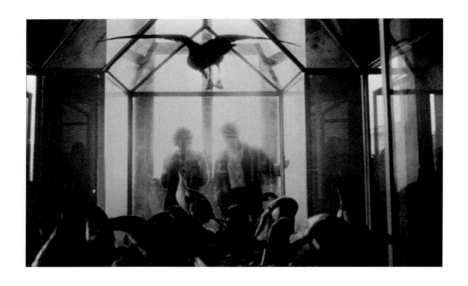

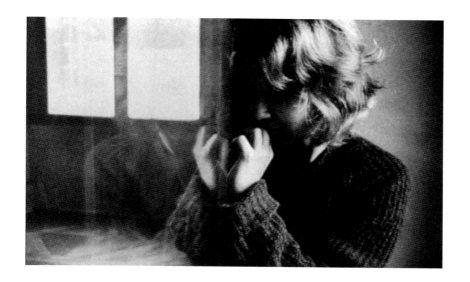

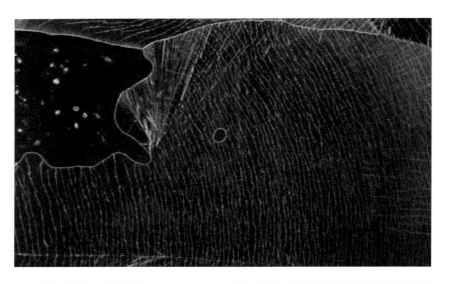

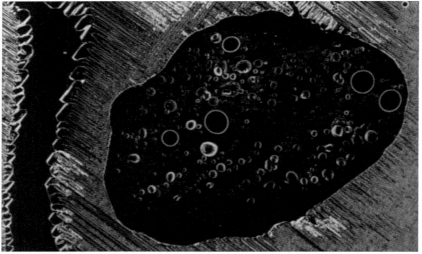

28—29.

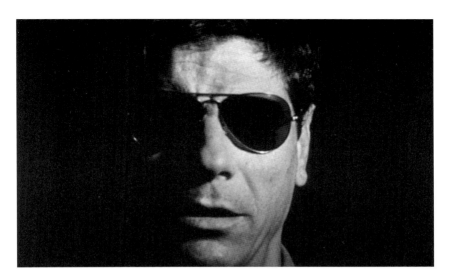

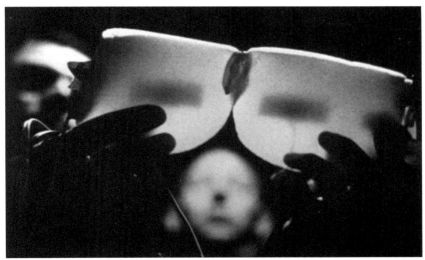

30 — 31.

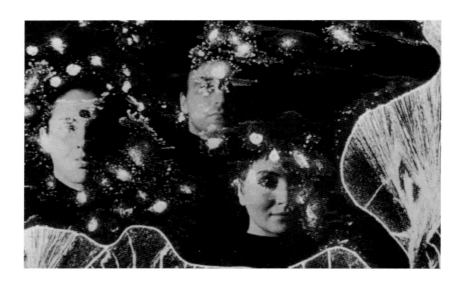

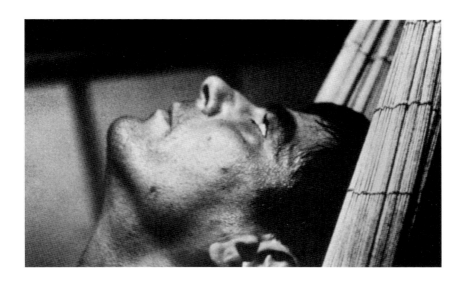

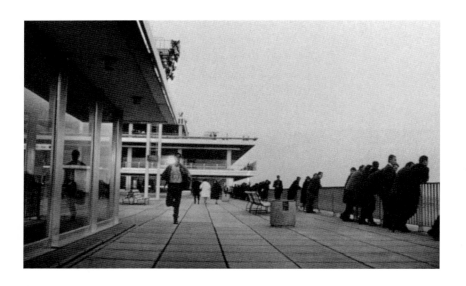

34.

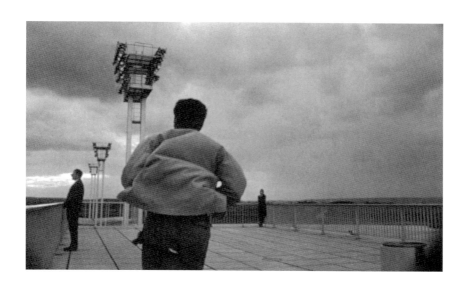

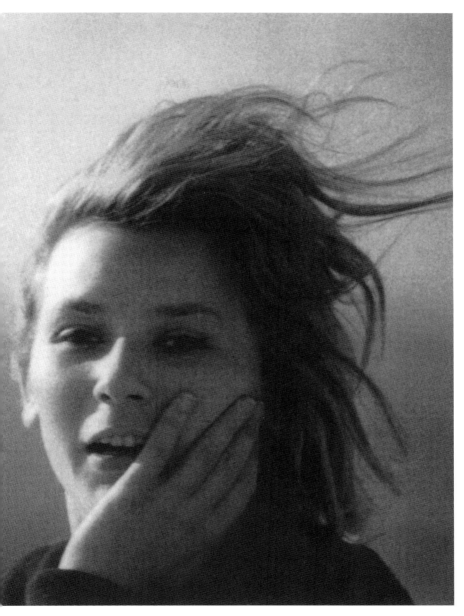

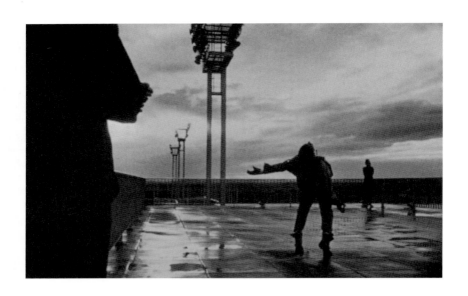

37.

openness. The emphatically gestural nature of the woman plays against its opposite, the attention to optical instruments as screening devices. The scenes in the underground camp shock with their disguise of the body, and the face in particular. The first image we see of a human being is a man standing next to an industrial pipe, lit from above so that shadows fall downwards across his face. He is dressed in combat clothing, a hood covers his head and strange optical devices that are like extended spectacles obscure his eyes. These optical instruments are worn by many of the camp guards, along with protective clothing. The body here is off-limits, but more so is the expressive nature of the face; we are denied the language of the body. Whilst the camp provides optical protection for its guards, the subjects of experimentation are exploited through the eyes. Theirs are attached to electronic conductors — simultaneously covered and utilised, as the experiment burrows into the subject through the portal of the eyes.

The gesture opens out onto an antagonism that not only pitches expression against silence, but a disembodied knowledge (retained by the guards) against bodily suffering (the subjects of experimentation). This opposition recalls an age-old conflict between a Platonic yearning to be rid of the body, a type of asceticism we see in the world of the camp and the future, and its opposite, idolatry and the worship of ideal bodies (statues). In various sequences of the film, in the peace-time images to the underground corridors, statues loom. The broken stone torsos recall the passion for bodies inherited through a past of pagan-inflected Christianity. The bodies of saints suffer and display their agony through injured bodies. In the middle of this film about a politically dystopian future, Marker installs a moment of religious dramaturgy. We should

not forget the first and last images of the man as the
falling figure on the pier, arms outstretched like a great
bird, or like a crucifix. The potency of *La Jetée* is in the
movement between these terms, of an embodied suffering
pitched against a disembodied knowledge, a gestural
cinematic language against a cinema of words. Statues
remind us of the sanctity of the body but also realise its
petrification, the vulnerability of the body to suffering
and the ravages of time, forces that come to waste us all.
Bodies can only be out of time when they are cast in stone,
or they are embalmed. And so, a line runs from statues
and fragments of worship to the museum where the living
walk amongst the dead, and brings together the forms of
the body's afterlife.

It is no accident that the sequence in the museum has
the least narrative voice-over. The museum is the place
of expressive display. The spoken narrative falls away
in this scene full of strangely beguiling creatures, and
the language of the human gesture takes over, carried by
a sweeping musical track. There is something comically
reciprocal in the gestures of the animals and the
two humans. The man and woman point, laugh, peer
underneath and around the displays, and their animated
language seems a response to the gestural poses of the
animals. The animals seem poised, prepared to be captured
photographically at some decisive moment in an activity
that is telling, an act both of revelation and communica-
tion. Through gesture the inert takes on a form of life,
an ability to provoke, to engage, to elicit a response.

The woman, more than the man, is engaged by these
creatures. The man is engaged more by the woman, and it is
as though she knows this, that through her communication

with these creatures she is drawing him towards her.
In a shot where the woman looks into a cage — the image
is shot from the side and slightly behind her — she has
lifted her hair to expose the nape of her neck. It appears
to be an invitation. The man looks at her exposed nape
in one of the most erotic images of the film. It is as
though he is about to lean forward and kiss the skin.
But the next shot is of the hostile stare of a cat. 'The girl
seems also to be tamed', the narrator comments, but this
is not exactly what we see. The girl is a woman and the
woman is playful, flighty, teasing, linked somehow to
cats and, in the following sequence of images, to birds.
The final room contains a spectacular collection of birds,
a few suspended in flight, but many organised in rows
behind glass. The spectacle of the birds — their sheer
number — refers us back to the bird sound of the bedroom
scene. If this multitude of birds could sing, that is what
they would sound like.

As a room full of gesture, the museum seems to offer the
possibility of correspondence, to lay bare the means of
communication across or within species. The animals
and the humans communicate something to another, any
other, not with a purpose but as an act of communicability
through bodies. For Agamben, the cinema rekindles a kind
of ethics in the ability to correspond through the body.
The language of gesture that has been lost is not a means
to an end (I dance because I want payment, is the example
he gives), nor is it an end in itself (I dance for dance's
sake). This binary, of means versus ends, blocks our view
of a third term, the gesture, which has the function of
supporting a correspondence with others. The cinema
shows us the art of communication as support.[53] It is
a disinterested gesture that is not simply for itself but

directed towards the other. Marker's use of gestural language reverberates the form of early cinema, the historical moment that was obsessed with the gesture just as it was in the process of losing it. Particular sequences of the film also echo the disinterestedness of the ethics of gesture that Agamben speaks of. In the museum, the characters move with no particular purpose, elaborating what it is that cinema can do without the drive of Aristotelian logic. Released from the constraints of time, the man and woman are also released from the means to an end of narrative cinema: they have 'no plans'. Their involvement is less like drama and more like a game, a series of open possibilities where the rules are made up in the exchanges between them: 'nothing is being produced or acted, but rather something is being endured and supported'.[54]

The accumulation of gestures in this sequence is connected to the collection of artefacts in the museum. Both cinema and the museum have a privileged relation to modernism and its contradictory understandings of time. On the one hand, modernist inventions work to rationalise time, to make it meaningful, to drive a narrative towards a conclusion, similar to arranging artefacts into a meaningful sequence. But, on the other hand, both cinema and the museum threaten to hollow out the purposefulness of time.[55] Cinema is also empty time, time used up, just as the museum is a dead store-house for the past. The energy of accumulation and rationalisation folds over to reveal its opposite, the potential meaninglessness of images that escape purpose, and the abstract structure of collecting, in which classification appears a ridiculous imposition. *La Jetée* operates in this space between the two dimensions,

mobilising both. Images, or more precisely photographs, are both random and purposeful, a proliferate flurry of non-meaning and a precise register of effects. In this sense, Marker's film delivers a prolonged hesitation between the image and its meaning.

There is yet another way in which ethics surface in this sequence, and that is in terms of hosting the other. In two shots the camera is positioned within the display case, looking through the glass at the curious figures of the man and the woman. We look at the man and the woman as though we were the animals, as though this is what it would feel like to view 'us' from 'there'. This exchangeability of positions is not an anthropomorphism, a making same of people and animals; it keeps difference in place, but, in so doing, the question of alterity is evoked. In another shot the camera is positioned high up, above a bird displayed with wings outstretched. Again, the human-animal perspective is reversed. This quiet address of an ethics of relating to the other concerns that which Derrida has named hospitality, the question of how one invites an other into one's world, and how one experiences the difference of others.[56] In the museum, the narrator informs us: 'She welcomes as a natural phenomenon the ways of this visitor who comes and goes, who exists, talks, laughs with her, stops talking, listens to her, then vanishes.' Here, the temporal difference that distinguishes the world of the man from the world of the woman as 'alien' stands for all differences, and raises the question of what it means to host an other. Hosting, for Derrida, holds a violent possibility that the host will make the guest conform to the host culture until the otherness of the guest is erased or consumed. Thus there is a possible monstrousness to the seemingly benign act of hosting,

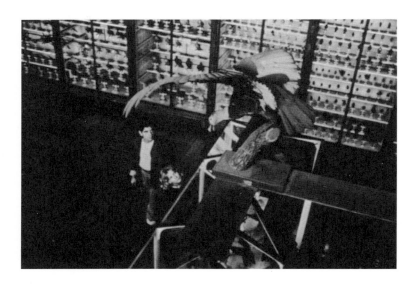

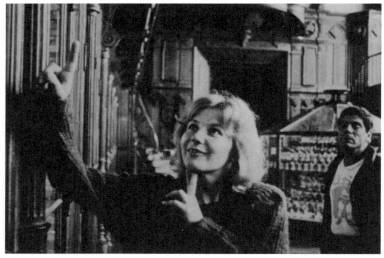

La Jetée,
35mm black-and-white film,
mono, 26min 37sec, 1962

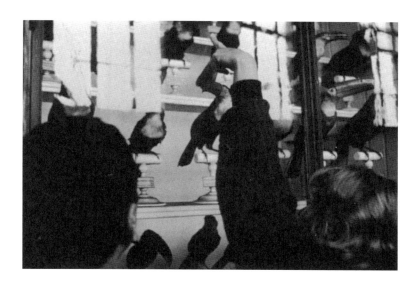

but *La Jetée* offers a different view. The woman exhibits
an openness, commensurate with her open physical gestures
towards him. She does not insist that he obey her rules
or conform to her customs, she simply listens and in turn
is listened to. She welcomes him, without the clauses and
demands implicit in the term 'hospitality'.

Earlier, in the park, we are given a sense of her bearing:
'She welcomes him in a simple way. She calls him her
ghost.' The simplicity of the act of naming belies the
complexity of the act of accepting an other into one's own
world. Calling him her ghost names the uncanny haunting
relations with the other, but also allows his difference
to exist.[57] As a ghost, he is allowed the freedom to vanish
— that is, to come and go. The temporal difference of the
film is itself haunted by another kind of difference
implicit to the displays in the museum. The collection
of 'exotic' others — here animals — stands in for colonial
others and the exploits of French imperialism. Marker
had already critiqued French colonialism in another film,
Les Statues meurent aussi (*Even Statues Die*, 1953), in which
African art shorn from its context is seen to wither and
die in the museums of France.[58] African art is forced to
submit itself to the violence of the host culture. In *La Jetée*,
the question of otherness is kept alive, and given greater
possibility through the metaphor of the time traveller
who can come and go, who can be 'elsewhere' and return.

Song, Birdsong and Noise
On the face of it, Marker offers us a story relayed with
clinical precision and an authoritative delivery. Yet there
is also something of the fable in the narrator's address,
the framing of a story precisely as a story in order that we
understand there to be another layer of meaning. Whether

the childhood voice of bedtime stories or the omnipresent voice of history, the narrator not only narrates the story but tells us that he is telling us. The 'child whose story we are going to tell', he reminds us early on, mixing up the ownership of the story: does this story belong to the child or the man? Later, with attention to temporal difference, he says: 'He was the man whose story we are telling.' That *was* the time of the subject, this *is* the time of telling, a gap that cannot be closed but that is also only a conceit of storytelling. 'Then', the past, becomes meaningful only in a present re-telling. Coiled together here are two important points: one concerning the tense of the narration, the second being the imputed distance between the narrator and the story told.

In the use of a double-tense structure, insisting on the now of telling and the past of the event, Marker creates two time frames. The double-time frame transgresses the general rules of narrative cinema — that cinema must appear to operate in the present, as though the unfolding film were happening before us right here and now. In his presentation of a time of event and a time of telling, Marker evokes cinema as a recording device, with the concomitant knowledge that this present (of the telling) has also already passed. The narration reminds us that time is an effect of language. The spoken word acts, to recall Flusser, like the written word, inserting a linearity into the experience of time: the verb-forms place acts and states of being within a frame-work of past, present and future. Yet, in foregrounding the various tenses of the time of the action and the time of telling, Marker underscores both the power of language to order time and its precarious grasp of temporality. That is, language, rendered here as a device of temporal

construction, is no more than a framework placed around the images, giving the effect of separating their different temporal registers. At the edges of the story is a sense that both words and images are flimsy fabrications of time. At best, words and images sculpt time, craft it into shapes and frameworks, but these bear little relation to subjective experience. Language and images do not hold or contain this substance, but possibly they present a tentative consensus about how time will be displayed, performed and acted out.

In the narrator's insistence on the 'now' of telling, there is, of course, a type of truth. Each time the film is shown, the time of telling is the present. But by the same token, the present is also moveable, a reiteration of a 'now' that can in fact be spoken at any time, and is delivered at every repeated exhibition of the work. In the gap between the time and the record of the time lies a wealth of speculation. In it the narrator's voice appears to us as a form of ventriloquism, mimicking a self-presence that is always escaping from the moment of utterance. The film opens with the line 'This is the story of a man marked by an image of his childhood', setting us within a framework of fiction and telling, a framework that is invoked again later in the film as a reprise, a repeated phrase. Like many of Marker's films, the voice-over rests on an assured authority that is only assumed, a conceit of knowing and telling. Unlike the majority of Marker's other films, *La Jetée* is purposefully presented as a fiction, but in a vocal style of delivery marked by a formal flatness. In the English version, the voice could be the tonally clipped yet dramatic register of a historical documentary from the late 1950s.

Perhaps this is no surprise, this playful discord of the fictional story and factual telling. Marker's documentary oeuvre deploys the tactic again, only in reverse: where facts are given, a story must be made. If facts circulate in our culture as what-has-been, they appear immutable, producing a condition that can be paralysing. 'What is always given in the media is the fact, what was, without its possibility, its power: we are given a fact before which we are powerless,' Giorgio Agamben has said.[59] In this combination of factual delivery and fictional story, Marker demonstrates that facts are not the opposite of fiction. And facts, often paraded as information, do not stand alone. In a commentary on the documentary *Le Tombeau d'Alexandre* (*The Last Bolshevik*, 1992), one of Marker's later films, Rancière argues in favour of the film's fictionalisation of the past: 'Memory must be created against the overabundance of information as well as against its absence.'[60] We must not, it seems, mistake memory or facts for the real. The extravagantly factual style of narration in *La Jetée* performs the tensions implicit in the authoritative voice-over form, its relating of past events and the fiction implicit to telling. Does it appear, as a double bluff, to be more 'factual' because of its referential notes to self that tell us that we are being told a story? Maybe so, but we also know that the images at times get away from this bluff narrator and flaunt the powers of his description.

There is the image and the narrator, and also something else to contend with, other sounds that make up the full audio-track. There are diegetic sounds, but only in two instances does the film release us into the sound of the scene: the aircraft engines and announcements at Orly that open and close the film. Rather more prominent is

a collection of sounds that reside on the cusp between the diegetic and the imaginary:[61] the man's heartbeat, the whispering of the experimenters, the hum of an industrial generator, the birdsong of the bedroom scene (although the latter is rather singular in its surreal quality). The other sounds of the film are musical, the Russian Orthodox Choir (of the cathedral St Alexandre Nevsky in Paris) and stock music composed by Trevor Duncan. There is also the 'noise' that accompanies the voice recording, a rush of sound that recalls the interference of a radio frequency. The use of the various forms of sound appears to be structured. The choir presents a dramatic height in music that supports the highest points of drama in the film, giving a sense of immanent transcendence to the event of the man's death. The sounds that exist in a sphere where diegesis overlaps with the imaginary belong mostly to the scenes in the present: the man's heartbeat evokes both fear and anticipation, the generator thrums as a menacing reminder of the failing industrial legacy of the past and the whispering injects a kind of paranoia about the events taking place as experiments. The sounds in the camp position us inside of the body of the man whose eyes are covered: we hear the internal noises of the body and the sounds of the exterior voices. Here, sound puts us in the place of the man in a way that the image cannot.

The use of stock music is perhaps the most surprising element of the soundtrack. The choice of Duncan, a British composer of that kind of light music that had been popular in the early part of the twentieth century, pushes the film towards a generic sound. Or, to come at the subject differently, Marker's use of stock music is perhaps analogous to his use of found images. Works that are archived as stock have a type of arbitrary value that leaves them open to

appropriation, as though they have no context other than as a classification code in a file. This rather bland stock music is used extensively in two scenes, the park and the museum, and both are in the past. It is also used briefly in an early scene in the camp, accompanying the image of the hollowed-out face of the man undergoing the experiment, and it finds a place fleetingly in a scene of the future. In the scenes of the past, it gives a blousy ambience, recalling Hitchcock's use of composed sound to lift the mood of a film into a sweeping and sublime optimism, or to add a menacing edge to events. The soundtrack draws on these somewhat standard tropes — repeatedly using a chime, for example, in the scene in the park where the man watches the woman and muses on the 'fact' that from the perspective of the world of the camps, the woman is dead. Against a flowing orchestral sound, the repeated chime literally sounds a warning note. The pre-composed score provides a fullness to the film in these moments because it knowingly deploys the formal mechanisms of cinema, of a particular hinging of sound to image. But this is only for certain stretches. Once through these, we are back to a 'thinner' and more noticeable use of sound as a process of patching in and fading out, of sounds that are inside the body and external to it.

What we hear and pay attention to is, then, variously the voice of the narrator, diegetic sound and music. But in this film from another time, there are other sounds we experience. These are sounds of the medium of recording, the audio-technology of 1962. The recording system that brings us the voice, in particular, carries with it the sound of interference, a white noise that switches on and off as the sound track of the voice is brought up and again recedes. This type of noise has largely been eliminated by digital

techniques of recording and washing sound, but here
it is still present. Noise has a particular importance,
albeit unwittingly. Rather as the still photographs bring
something of the visual recording technologies into view,
noise refers us to the sound technologies that mediate
and translate communication. If sound recording is not
simply a faithful record but 'corrupted', it is a corruption
nonetheless that makes us listen all the more attentively.
'We are surrounded by noise,' Michel Serres writes, 'and
this noise is inextinguishable. It is outside — it is the
world itself — and it is inside, produced by our living
body'.62 These are the sounds of the world and ourselves
that are neutralised by our having learnt to exclude them,
to push them out of the register of meaningful exchanges.

This crackle and hiss of noise on the soundtrack seems
to oppose the communicating voice and its eloquent
signification. But Marker's use of sound lets in a leakage
of various kinds of noise — sounds that are excessive
to communication, unruly and often ruled out for that
very reason.63 To include them in the sound design of the
film, in addition to their unintentional presence in the
narration, suggests that noise is meaningful, affective.
The internal sound of the heartbeat, a sound of both the
body's fear and steady endurance, generates tension in the
scene of experimentation. The generator thrums at a low
level underground, and this seems to blend into the fuzzy
static of the recording technology. It may not be the case
that Marker intended to foreground the white noise of the
audio tape, yet its effect is to mirror the foregrounding
of film and photography as material practices. White
noise, like the grain of the image, is the fabric of media.
Its presence reminds us of the chaos hovering over acts of
exchange as a condition of transmitting communication

across time and space. The matter of noise and of grain and of frame forces us to engage with this film as a fabrication, its construction conditioned by its material form.

Endgames

We move, in *La Jetée*, among broken statues. There are other signs of desolation: a graveyard and ruins. But statues return throughout, not quite so readily assigned simply to the place of destruction. They come back in their fragmented forms, their bits and pieces of stone bodies, holding a repose that belies the fracturing of form. The first few appear in the sequence of peacetime images, a stone torso without a head and a head with a featureless face, bathing their faceless or limbless forms in a soft sunlight. In the catacombs they are in shadow: a small cherub is seen first from the side and then from the front a few frames later, when we notice that he is dragging what appears to be a goose under his left arm. This small figure's nakedness is a sign of innocence, perhaps, and completely out of place here. And then, still in the catacombs, there is a statue of a man, a saint possibly, his head draped in cloth as though he has been put into storage. These figures from another world, the casts of a human form and yet made of stone, caught in animated gesture and yet fixed for eternity, they show us, like photographs, a life in death. Like ghosts, they trouble the boundary between the past and present, the animate and inanimate, human matter and organic form. Referencing antiquity and all of the best that has been said and done, the mode of the statues is classical. Their purpose here, in this story of apocalypse and all of the worst that can be imagined, dreamt or forecast, is to make us mindful of a different ambition. And they remind us that the past lives on in the present in their stubborn mixing of temporality.

La Jetée,
35mm black-and-white film,
mono, 26min 37sec, 1962

Marker has said of another work, *Le Joli mai*: 'This film
… would like to offer itself as a fish tank for the future
fishermen casting their nets into the past.'[64] Yet this
appears to describe not just this film, but his practice more
generally. Is this transparent container not the condition
of photography in time, the souvenir sent like a postcard
into the future? The moment of the taking of a photograph,
is it not a time written to an other, the other, the future
self or other future beings? This is the motive of all
archiving: to 'stock in anticipation', to gather the past
and present into a sensible state for a prospective future
viewer.[65] In *La Jetée*, Marker incorporates this paradox
into the structure of the film: the capturing of the present,
which will soon (immediately) become the past, is in
fact directed at the future. The film is, in a sense, a lesson
in archiving, in the institution of cinema as an archive,
bent on its own rules of selection and exclusion. Cinema,
like history, like archives, must gather the materials for
the telling of a story, for a future narration to be possible.
How the past is shaped and coaxed into being in the present
for future viewers is the work of the film-maker.

What do you remember, Marker was asked recently,
of *La Jetée* and *Sans Soleil*? 'If I were to speak in the
name of the person who made these movies,' he responded,
'it would no longer be an interview but a séance.'[66] Ghosts
once again. The film-maker who began *La Jetée* on a day
off is now a distant and unknowable figure. Time produces
its own kind of alterity. Yet it is not only time but naming
that is an issue here. The reluctance to 'speak in the
name' of a self from forty years ago disguises the fact that
Marker has rarely spoken in the name of a film-maker,
and has only ever spoken under an adopted pseudonym.
Chris Marker: the name is a fabrication, a screen.[67]

Maybe his refusal of the label of auteur is a political point, or, less seriously, a private joke cooked up among friends. Or simply, it is the practice of a privacy that has endured. To ascribe anything much to the film-maker has a precarious feel, as though invoking the name of the person behind the camera raises the question of our fantasy rather than anything on the other side of that screen. If Marker is to be understood as precisely that — a mark, a signature, a signing that has no available referent for us to attach it to — then perhaps we need to ask whether 'Marker' might not be the name we have come to use for a problem of the relation of images to memory and time. In a period in which the production of images has proliferated, and Marker's oeuvre of some 78 films illustrates that point, we might wonder what it is that we want from images as we go on making, circulating and watching them.

The pressure on cinema to provide a visual history, and to bear witness to events, could not have been more powerful than in the post-War European context. Marker's engagement with the drastic interruption of continuity that was World War II, and the drastic interruption of thought with the Holocaust, took place in an earlier part of his career. Working with scriptwriter Jean Cayrol, Marker co-wrote the commentary for Resnais's *Night and Fog*, a film that returns to Auschwitz ten years after the liberation. Mixing contemporary images with archive stills and footage, the narration articulates questions of memory as place. In its construction (the design detail of watch towers, the process of organising the building works), we find that these very 'mundane' matters facilitate this most extraordinary event.[68] Place is the retainer of traumatic memory if we know how to look. In one of the final images of the film the camera moves across the

surface of a ceiling in a chamber. The narrator says this: 'The only sign — but you have to know — is this ceiling, dug into by fingernails.' The sentence hangs in the air in its ambiguity, or its fullness of meaning — 'you have to know' inferring that you need to be told for the nail marks to become legible. And it signifies again: 'mais il faut savoir', because this needs to be told, you need to bear this knowledge from the past. The question of what we can bear to know of the past, and of what this means for the future, is laid before us in this moment. At the centre of this circle of questions is the place of images, their ability, or not, to retain and pass on 'facts', trauma and meaning — in short, to deal in the ineffable.

In this context in which the unthinkable has occurred, Marker's work with Resnais is an attempt to put thought, history and cinema into direct relation, to produce a testament of sorts. In *La Jetée*, the project has become one of re-assemblage and recreation. The film tells the story of a fated humanity, bare life existing in camps underground, the earth toxic with radiation. The historical referents are in place, but this is a fable. Not a document(ary), but a story offered up, and with the warning that it is not possible to return to a time before the event. Images cannot bear witness, but they can connect us to the past through a process of assemblage. In approaching the past, there is the referential (inaccessible) real and the heterogeneity of documents to deal with, but there is also story. *La Jetée* allows cinema to be (at least) two fundamental things, defining terms that commonly are set in opposition: on the one hand, cinema is document, inscription of time, the capture of life in the deathly record; and on the other, cinema is montage, a complete irreverence for time, displayed

La Jetée,
35mm black-and-white film,
mono, 26min 37sec, 1962

through the re-assembling of parts, firing off a seemingly infinite range of affects with no respect for their origins. In this sense, *La Jetée* is properly a 'science fiction', a hybrid of clashing ideas about what fiction and fact can be, and a *photo-roman*, a hybrid of ideas about what photography and literature might forge together. It is not that Marker treads a line between these, but, rather, that he demonstrates how irrelevant such a line may be, both for our ideas of what constitutes cinema and our comprehension of what time may be.

The final sequence of the film sets these terms into relation with one another expertly. The scene is Orly Airport, and we, too, are returning to a scene we have experienced before, but this time we are in the place of the adult. As the man arrives on the steps to the pier, the scene is one of crowds, people strolling on a Sunday afternoon. It is a scene of a story that we are following with anticipation and even expectation, given what we know. But in this moment an image jumps out of the film as a referent to the outside of this fiction. The image is of the protagonist at the foot of some steps, but in the foreground is a young girl, holding the hand of a man who is out of frame. The details of her clothing are tangible: the smock dress with the embroidered crosses, the patterned cardigan, the hair tied up in bunches, her other hand clutching a bag. I am reminded of Roland Barthes at the wonderfully tortured and hallucinatory end of his essay on photography, when he declares about photographs, 'whoever looks you straight in the eye is mad'.[69] The child gazes directly into the camera, breaking the spell of the story with her unremitting, lacerating stare. But perhaps I am also at the stage of image hallucination. A more equivocal view would be that the child invited the moment

of when 'two looks meet in a kind of equality'.[70] In the staging of a fiction, this child steps outside of it and places herself as a subject in time, and in history. But she also performs a kind of revelation in her facing into the camera, echoing the small boy of the opening sequence, whose back we see but whose face is kept from us.

If the referent of the real surfaces, momentarily, it is lost immediately after to the sequence of the action — to the man running, to his desire to find the woman and to his sighting of the camp guard. In this moment of heightened drama, a philosophical investiture occurs: 'he knew there was no way out of time'. And with this the choral music swells and then subsides with the image of the falling figure. The film is over, done. It fades to black. The connections are made and fixed, so that the process of editing effects the same finality as death. Pier Paolo Pasolini drew this analogy between life and film production, between all of the possible meanings in life that remain open until death, and the possible meanings of film that are fluid until the assemblage has done its work: 'Editing therefore performs on the material of the film … the operations that death performs on life.'[71] Yet Pasolini wasn't thinking about the film as an idea and an object, a thing constantly coming into being in time.

The film has a future beyond us. We are temporally delimited viewers who are merely figures in a snapshot of film-viewing — its future ghosts. *La Jetée* has a life beyond us as an object with a different lifespan. As a text, it doesn't stay the same but transmutes, moving sideways into other objects and spaces. In an irony that belies the title of *One Work*, *La Jetée* is also a DVD, a book of stills and text, a cartoon, a bar in Tokyo, a pastiche in a music

video, the predecessor to a full-length feature film and a re-edited version on video now said to be lost.[72] It is a film heavily copied and reproduced, playing on Internet sites where the distinct chiaroscuro has faded to a palette of muted greys, and there are other kinds of non-diegetic sounds in its mix. One work has proliferated, multiplied across various media and locations, different parts of it extracted and reworked. The project of assemblage goes on as more meanings are generated. When we come to it again, in these various manifestations, it is changed and so are we.

1
The movement across the image mimics the sensation of the forward-zoom-reverse track shot favoured by Alfred Hitchcock in *Vertigo* (1958), and again notably by Stephen Spielberg in *Jaws* (1975). Marker achieves the same sensation by reversing expectations in several ways. As we zoom out, it is only the left field of vision that opens up, causing the eye to read from right to left, cutting across the customary (European) direction of reading. We are also pulled into reverse by moving from a detail to a wide shot. At the beginning of a film, the expectation would be for the camera to move from a wider shot, for example of a city, towards a significant detail, such as a building or window.

2
In researching the film in the Belgian Cinémathèque Royale, Philippe Dubois came across a print of the film that opens with a moving-image sequence. The reasons for changing the opening of the film may have been to give greater prominence to the one sequence of movement in the film, or to open the film with a more conflicting relation between movement and stillness. Cited in Catherine Lupton, *Chris Marker: Memories of the Future*, London: Reaktion Books, 2005, p.226. See P. Dubois, 'La *Jetée* de Chris Marker, ou le cinématogramme de la conscience', *Théorème*, no.6, 'Recherches sur Chris Marker', 2002, pp.9—45.

3
Friedrich Nietzsche, *On the Genealogy of Morals* (trans. Walter Kaufmann), New York: Vintage Books, 1967, p.58. Nietzsche's concept of forgetting may be thought of alongside Derrida's *sous rature* as the deletion of a term that remains legible nonetheless.

4
This citation of Kafka is used by Roland Barthes in *Camera Lucida: Reflections on Photography* (trans. Richard Howard), London: Vintage, 1993, although the translations of the phrase vary slightly. Interestingly, Barthes follows this citation with attention to sound: 'The photograph must be silent (there are blustering photographs, and I don't like them): this is not a question of discretion, but of music' (pp.54—55).

5
Marker has called *La Jetée* a remake of the Hitchcock film. In a further twist of recall and versioning, it has been suggested that Hitchcock's naming of the woman Madeleine in *Vertigo* could refer back to Proust's famous madeleine moment. See Mark Fisher's discussion in 'Six Re-Views of Chris Marker: The Art of Memory' in *Metamute*, December 2002, and Burlin Barr, '"Wandering with Precision": Contamination and the *Mise-en-Scène* of Desire in Chris Marker's *Sans Soleil*', *Screen*, vol.45 no.3, 2004, pp.173—189. In the DVD *Immemory* (2002), Marker asks: 'What is a madeleine?' The question is accompanied by an image of both Hitchcock and Proust.

6
Although many of Marker's films are critical of political history, Marker creates a division between these terms, describing his interest in the marks of history rather than politics. See Samuel Douhaire and Annick Rivoire, 'Marker Direct' (trans. Dave Kehr), *Film Comment*, special edition 'Around the World with Chris Marker: Part II Time Regained', vol.39 no.4, 2003, p.40.

7
C. Lupton describes *La Jetée* as 'turning the documentary adventure of *Le Joli mai* inside out, distilling its subterranean fears and anxieties about the future into an elegiac masterpiece of speculative fiction', in C. Lupton, *Chris Marker*, *op. cit.*, p.78.

8
S. Douhaire and A. Rivoire, 'Marker Direct', *op. cit.*, p.40.

9
Fredric Jameson, *Postmodernism, or, the Cultural Logic of Late Capitalism*, Durham: Duke University Press, 1991. Against Jameson's diagnosis of a crisis in historicity, Giorgio Agamben argues that 'the dialectic is quite capable of being a historical category without, as a consequence, having to fall into linear time'. See G. Agamben, 'The Prince and the Frog: The Question of Method in Adorno and Benjamin', in *Infancy and History: Essays on the Destruction of Experience* (trans. Liz Heron), London and New York: Verso, 1978, p.123.

10
Karl Marx, writing with Friedrich Engels, famously connected ideology with the camera obscura: 'If in all ideology men and their circumstances appear upside-down as in a camera obscura, this phenomenon arises just as much from their historical life-process as the inversion of objects on the retina does from their physical life-process.' See *The German Ideology* (ed. C.J. Arthur), New York: International Publishers, 1970, p.47.

11
G. Agamben, 'Difference and Repetition: On Guy Debord's films', in Tom McDonough (ed.), *Guy Debord and the Situationist International: Texts and Documents*, Cambridge, Mass. and London: October and The MIT Press, 2002.

12
Jacques Derrida, *Archive Fever: A Freudian Impression* (trans. Eric Prenowitz), Chicago and London: University of Chicago Press, 1995.

13
The man is played by Davos Hanich, a sculptor, in his only film role, and the woman by Hélène Chatelain, who worked in community theatre and film and was the partner of the playwright Armand Gatti.

14
Night and Fog is a documentary assembled from German images, images from the allied campaign and Resnais's post-War stock. This project

marked the beginning of Marker's career as a film-maker/director. Prior to this, he had what might be considered a serious career as a writer, publishing a novel, articles, essays, translations, poems and short stories.

15
Marker shot the underground scenes beneath the Palais de Chaillot, built in 1937 for the Exposition Internationale. The building houses a number of museums and is decorated with verse from the poet and philosopher Paul Valéry. Benjamin was to cite Valéry at the beginning of his essay 'The Work of Art in the Age of Mechanical Reproduction' (1936), itself a meditation on the properties of photography and film that returns us full circle to Marker.

16
'A touch of the finger now sufficed to fix an event for an unlimited period of time. The camera gave the moment a posthumous shock, as it were.' W. Benjamin, 'On Some Motifs in Baudelaire', *Illuminations* (ed. Hannah Arendt, trans. Harry Zorn), London: Pimlico, 1999, p.171.

17
The choral music is a recording of the Russian Orthodox Choir of the cathedral St Alexandre Nevsky in Paris.

18
Curiously, there is a continuity issue in the final sequence, noticeable on the paved surface of the pier. In the majority of the sequence it is dry, but in the few shots of the body falling backwards, the ground is wet and the sky dramatic. Fittingly, what passes as a linear sequence reveals itself in its detail to be of a mix of times re-assembled.

19
C. Marker, written foreword to the DVD *La Jetée/Sans Soleil*, Nouveaux Pictures, Argos Films, 2003.

20
P. Dubois, 'Photography *Mise-en-Film*: Autobiographical (Hi)stories and Psychic Apparatuses' (trans. Lynne Kirby), *Fugitive Images: From Photography to Video* (ed. Patrice Petro), Bloomington, Ind.: Indiana University Press, 1995, p.152.

21
R. Barthes, *Camera Lucida*, *op. cit.*, and André Bazin, 'The Ontology of the Photographic Image', *What Is Cinema? Volume 1* (trans. Hugh Gray), Berkeley: University of California Press, 1967.

22
Vilém Flusser, 'Photography and History', *Vilém Flusser: Writings* (ed. Andreas Strohl, trans. Erik Eisel), Minneapolis and London: University of Minnesota Press, 2002, p.128.

23
It is notable that the only written texts we see in the film are graffiti —
in each case spatialised and given texture on a wall, rather like a tableau.
The spoken (rather than written) word of the story provides the tension
between the linearity of the story and the a-temporal tableau of the image,
as Flusser would see it.

24
V. Flusser, 'Photography and History', *op. cit.*, p.128.

25
Siegfried Kracauer, 'Photography', *The Mass Ornament: Weimer Essays*
(ed. and trans. Thomas Y. Levin), Cambridge, Mass. and London: Harvard
University Press, 1996, p.58.

26
See, for example, Michel Foucault's discussion of similitude in 'The Prose
of the World', *The Order of Things: An Archeology of the Human Sciences*, London
and New York: Routledge, 2007.

27
V. Burgin, *The Remembered Film*, London: Reaktion Books, 2004, p.105.

28
The authorship of the sleeping princess story is attributed to Charles
Perrault's *Stories of Olden Times* (1697). Of the many painted renditions
of the story, the turn of the century artist Frances MacDonald's *Sleeping
Princess* (1909) presents the heroine and a small, fairy-like figure, who
guards her and looks out of the picture. The image appears to engage with
similar themes to Marker's images of a sleeping woman in its concern
with attending the unconscious body of the woman and with the relation
between eyes that are closed and eyes that are open.

29
P. Dubois, 'Photography *Mise-en-Film*: Autobiographical (Hi)stories and
Psychic Apparatuses', *op. cit.*, p.153.

30
Uriel Orlow, 'Photography as Cinema: *La Jetée* and the Redemptive Powers
of the Image', *The Cinematic* (ed. David Campany), London and Cambridge,
Mass.: Whitechapel and The MIT Press, 2006, pp.177—84.

31
A rostrum is a specially adapted camera and mount, suspended over a
platform on which a still image is placed. In its movement over the
image, the camera is able to animate still images through the use of
zooms, dissolves, wipes and rotations. The process is now mostly replaced
by similar techniques achieved with computer software.

32
For a full discussion of Gordon's film, Hollywood and the avant-garde,
see Amy Taubin, 'Douglas Gordon', in Philip Dodd and Ian Christie (eds.),
Spellbound: Art and Film (exh. cat.), London: Hayward Gallery and British
Film Institute, 1996.

33
Cited in G. Agamben, 'Difference and Repetition: On Guy Debord's Films',
op. cit.

34
In 1958, before the making of *La Jetée*, A. Bazin wrote of Marker's practice
that the cerebral style of his montage was located in intelligence and
language, with the image lagging behind these two materials: 'I would
say that the primary material is intelligence, that its immediate means
of expression is language, and that the image only intervenes in the third
position, in reference to this verbal intelligence.' First published in
France in *Observateur*, 30 October 1958, reprinted as 'Bazin on Marker'
(trans. D. Kehr), *Film Comment*, vol.39 no.4, 2003, pp.44–45.

35
The influence of Soviet film-makers and their strategies of montage on
Marker's work has been widely commented upon.

36
S. Douhaire and A. Rivoire, 'Marker Direct', *op. cit.*, p.40.

37
Although dissolves and fades are two different techniques in editing,
they function in a similar way in the film.

38
Réda Bensmaïa, 'From Photogram to Pictogram', *Camera Obscura*, vol.24,
September 1990, pp.138–61.

39
This effect of coming upon the image again, but in a different context
that changes its meaning, is discussed (in the context of avant-garde film)
by Maya Deren. In her view, the film work performs a type of repetition
influenced by lyric poetry. See 'An Anagram of Ideas on Art, Form and
Film', *Maya Deren and the American Avant-Garde* (ed. Bill Nichols), Berkeley,
Los Angeles and London: University of California Press, 2001.

40
G. Agamben, 'Difference and Repetition', *op. cit.*, p.315.

41
See for example Francis Bacon's *Three Studies for Figures at the Base
of a Crucifixion* (1944).

42
Originally published in *Libération*, 5 March 2003, reprinted in *Film Comment*
as 'Marker Direct', *op.cit.*, pp.38–41.

43
For a discussion of this in relation to *Sans Soleil*, see Carol Mavor, 'Happiness
with a Long Piece of Black Leader: Chris Marker's *Sans Soleil*', *Art History*,
vol.30 no.5, pp.738–56.

44
Jean-Louis Schefer, *The Enigmatic Body* (trans. Paul Smith), Cambridge:
Cambridge University Press, 1995.

45
El Apóstol, made by Quirino Cristiani, was a political satire and ran at
14 frames per second.

46
See Emmanuel Levinas, *Totality and Infinity: An Essay on Exteriority*
(trans. Alphonso Lingis), Pittsburgh: Duquesne University Press, 1969.

47
The return of the look contrasts sharply with Barthes's sense of the cold
eyes of a photograph that belong to another time (see *Camera Lucida, op. cit.*).
For a discussion of the particularity of Marker's use of the returned look,
see Chris Darke, 'Eyesight', *Film Comment*, vol.39 no.4, 2003, pp.48–50.
Darke's discussion is guided by Marker's assertion early on in *Sans Soleil*:
'Have you ever heard of anything more stupid than what they teach at
film school — *not* to look at the camera?'

48
In a review of the film from its time of release, Ernest Callenbach finds
the woman (he calls her a 'girl') less than alluring, only becoming so
through the enigma of the film: 'The hero is brooding, wounded, the prey
of the experimenters. The girl, who at first seems plain, becomes achingly
beautiful because of that: no "beauty", she is terribly young, serious,
human.' See 'Short Films: *La Jetée*', *Film Quarterly*, Winter 1965–66,
vol.19 no.2, p.51.

49
G. Agamben, 'Notes on Gesture', *Means Without Ends: Notes on Politics*
(trans. Vincenzo Binetti and Cesare Casarino), Minneapolis and London:
University of Minnesota Press, 2000.

50
Régis Durand attributes gestural qualities also to still images, suggesting
that the photograph captures the trace of an unconscious desire: 'Images,
then, would be visible forms of such unconscious "feelers" — the visible
traces of unconscious "gestures". Not *illustrations* of them, but rather like
a rebus, a code which, even though it is no simple translation or figuration,
must have some affinity, some sense of connection with the original

impulse.' See 'How to See (Photographically)' in P. Petro (ed.), *Fugitive Images: From Photography to Video, op. cit.,* p.149.

51
In 1995, Marker made *Silent Movie,* an installation commissioned by the Wexner Center for the Arts in Ohio. The installation consisted of five stacked monitors playing twenty-minute films sequenced at random by the computer. The films were largely sampled sequences or images from films made before 1940. The five monitors had themes, one of which was 'The Gesture' (along with 'The Face', 'The Journey', 'Captions' and 'The Waltz').

52
Cited in Jacques Rancière, *Film Fables* (trans. Emiliano Battista), Oxford and New York: Berg, 2006, p.126.

53
G. Agamben, 'Notes on Gesture', *op. cit.,* p.59.

54
Ibid., p.57.

55
Mary Ann Doane, *The Emergence of Cinematic Time: Modernity, Contingency, the Archive,* Cambridge, Mass. and London: Harvard University Press, 2002.

56
Jacques Derrida and Anne Dufourmantelle, *Of Hospitality* (trans. Rachel Bowlby), Stanford: Stanford University Press, 2000.

57
The ghost is also a prominent figure in Derrida's writings, a figure prone to repetitious re-entries but also a spectre of the future 'to come'. See, for example, *Spectres of Marx: The State of the Debt, the Work of Mourning and the New International* (trans. Peggy Kamuf), London and New York: Routledge, 1994.

58
Marker made *Les Statues meurent aussi* with Alain Resnais in the years 1950 to 1953.

59
G. Agamben, 'Difference and Repetition', *op. cit.,* p.316.

60
J. Rancière, 'Marker and the Fiction of Memory', *Film Fables, op. cit.,* p.158.

61
Diegetic sounds are those that arise from the world of the fiction. Whether they are visible or off-screen, they appear to be part of the fiction. Marker uses a range of sounds that could be regarded as part of the fictional world,

or as part of the world of the narrator who is telling the story, as though the story were being added to and exaggerated in the telling.

62
Michel Serres, *The Parasite* (trans. Lawrence R. Schehr), Minneapolis and London, University of Minnesota Press, 2007, p.126.

63
Noise is not extraneous for Serres but an excess that is potentially creative because it disrupts, reminds us of chaos beyond total control and suggests a mode of relational living where excess or 'waste' is not only part of but partially constitutes the systems that we rely on. To a degree, noise for Serres is an excess similar to surplus value for Marx, or sublime excess for Georges Bataille.

64
Cited in C. Lupton, *Chris Marker, op. cit.*, p.87.

65
J. Derrida, *Archive Fever, op. cit.*, p.7.

66
S. Douhaire and A. Rivoire, 'Marker Direct', *op. cit.*, p.40.

67
The name was spelt Chris.Marker in earlier years. See C. Lupton, *Chris Marker, op. cit.*, p.9.

68
The mundane detail of the film resonates with Hannah Arendt's claim that evil is banal. For a full discussion of the film, see G. Agamben, *Remnants of Auschwitz: The Witness and the Archive* (trans. Daniel Heller-Roazen), Cambridge, Mass.: Zone Books, 1999.

69
R. Barthes, *Camera Lucida, op. cit.*, p.113.

70
C. Darke, 'Eyesight', *op. cit.*, p.49.

71
Pier Paolo Pasolini, 'Observations on the Sequence Shot', *Heretical Empiricism* (trans. Louise K. Barnett and Ben Lawton), Bloomington, Ind.: Indiana University Press, 1972. Frank Kermode writes of a similar desire for endings as the ability to impose a pattern on time in *The Sense of an Ending*, Oxford: Oxford University Press, 2000. Kermode draws on the relations between literature and apocalyptic thought.

72
Thierry Kuntzel's *La Rejeté* (1974) re-edited certain elements of the film into a new version (the title is a pun on *The Rejected/The Re-Jetty*).